LEGENDARY LOCALS

OF

PITTSBURGH

PENNSYLVANIA

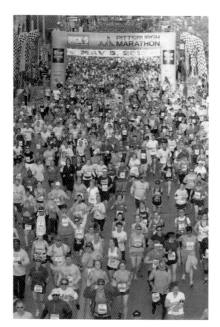

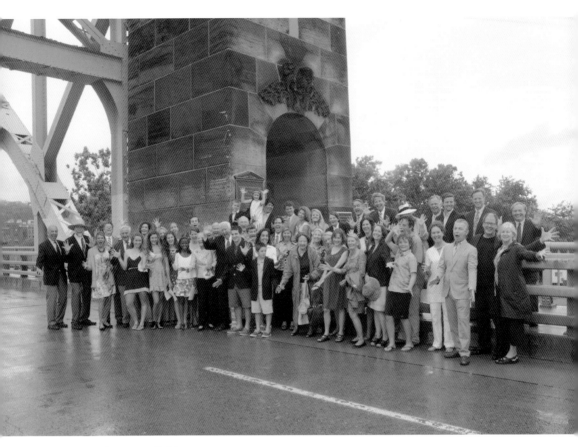

David McCullough Bridge
Historian and author David McCullough returned to Pittsburgh on July 7, 2013, with his family, in celebration of the renaming of Pittsburgh's Sixteenth Street Bridge in his honor. In McCullough's words, "History is who we are and why we are the way we are." (Photograph by Margaret Stanley; courtesy of Allegheny County.)

Page 1: Pittsburgh Marathon
More Pittsburghers gather in the city every May than at any other time of the year. The Pittsburgh Marathon highlights the rivers, the people, the music, the smell of great Pittsburgh food, and, most of all, the beautiful topography that defines our city. With more than 20,000 runners, greeted by thousands who line the streets and neighborhoods, the race is sure to include a legendary local in there somewhere. It could be you! (Courtesy of the Pittsburgh Marathon.)

LEGENDARY LOCALS

OF

PITTSBURGH
PENNSYLVANIA

JOANN CANTRELL

LEGENDARY
LOCALS

Legendary Locals is an imprint of Arcadia Publishing
Charleston, South Carolina

Printed in the United States of America

Library of Congress Control Number: 2013939641

For all general information, please contact Arcadia Publishing:
Telephone 843-853-2070
Fax 843-853-0044
E-mail sales@arcadiapublishing.com
For customer service and orders:
Toll-Free 1-888-313-2665

Visit us on the Internet at www.arcadiapublishing.com

Dedication
To the many legendary locals featured, and those unmentioned, with amazing stories to tell, and to all the people who proudly claim, "I'm from Pittsburgh!"

On the Front Cover: Clockwise from top left:
Reed & Witting Printers, 113-year-old Pittsburgh printers (courtesy of David Cyphers; see page 80), JulieHera and Jocqueline DeStefano, mother-daughter Pennsylvania Hero Walk duo (courtesy of Julie Hera DeStefano; see page 98), Donnie Bugrin, Children's Hospital of Pittsburgh inspiration (author's collection; see page 124), Fred Rogers, children's television host (author's collection; see page 34); Harold McKamish, cofounder of Caring Hearts Ministry (courtesy of Harold McKamish; see page 60), David and Ruth Miller, president and treasurer of The Society for the Preservation of the Duquesne Incline (courtesy of Norman Samways; see page 55), Margaret Samways, resident of Mount Washington and employee of Gulf Oil Corp. (courtesy of Norman Samways; see page 56).

On the Back Cover: From left to right:
Rick Sebak, television producer and documentary maker (courtesy of Rick Sebak; see page 102), Maurice Stokes, NBA legend (courtesy of St. Francis University Athletic Department; see page 87).

CONTENTS

ACKNOWLEDGMENTS

Many thanks to my family, friends, and Kirk Weixel for a lifetime of encouragement to write, and to the good people who immediately came up with lists and suggestions of people to include in *Legendary Locals of Pittsburgh*, such as Norman Samways and Dr. Michael Lamb. An aspect of Pittsburgh life is being connected, and one person led to another, and another, and another. Special thanks to Paul Armbruster, Ron Baraff, James Buckley, Ken Kobus, Chris McKelvey, Fran Joyce, Betty Lee Garver, Maddy Ross, and Rick Sebak, who were eager to help. Gratitude goes to Dr. Rodrigue Labrie, a teacher and mentor from St. Francis University, Loretto, who made a lasting impression, just like the legendary locals featured in this book.

Legendary Locals of Pittsburgh would not be possible without the tremendous help, assistance, enthusiasm, and creativity of Tinsy Labrie, a special friend and "legendary local" who has been one of Pittsburgh's biggest cheerleaders for decades. Sincere and heartfelt appreciation for her time and effort cannot be measured.

INTRODUCTION

Every city has a history that makes it unique and interesting in its own right. Yet, there are cities that somehow seem a little more unusual than others. They have that special something that makes a visitor ask, "Why does this place exist?" "What made people settle here?" "What do people actually do here?"

Pittsburgh, Pennsylvania, is one of those places. With its rags-to-riches pedigree, it has a story with the lowest lows, highest highs, and universally-agreed-upon proudest moments: in sports, including Franco Harris's 1972 Immaculate Reception; in politics, the hosting of the G-20 Pittsburgh Summit in 2009.

Pittsburgh is a mid-sized city that acts like a small town; with 305,000 city residents and a metropolitan population of 2.3 million, it is a place where one is easily recognized. Natives joke that the degrees of separation number closer to one or two rather than six. And that will not let you get away with too many shenanigans before being noticed by your friends, family, and colleagues. Knowing or being known by half the town is what keeps people grounded, in check, connected, real. Even with the city's 446 bridges, there isn't a lot of burning of them in the figurative sense. Your personal and professional history stay with you in Pittsburgh, and it was that way long before the Internet documented everything.

All 90 of Pittsburgh's neighborhoods have a persona. Being from Lawrenceville means something totally different than being from, say, Point Breeze. But in Pittsburgh, the twain meet more often than not, as a guy from Glen Hazel and a native of Greentree can often be found gathered at the same watering hole on any given hockey night, raising an Iron City beer and cheering, "Let's go Pens!"

Pittsburgh's been called a lot of things, including the Steel City, City of Bridges, City with a Smile, and the Most Livable City. It was chosen as one of the Best Destinations in the World to visit by *National Geographic Traveler*. Pittsburgh has found itself at or near the top of lists for everything from most literate to most secure; from one of the best places to retire to the best for raising a baby; for being eco-friendly, affordable, underrated, clean, improved, fun, pretty, bike-friendly, and time-saving; for having the best ballpark, airport, children's museum, kayaking, city parks, concert hall, and views at night. Locals aren't fazed by all this praise. They think it is nice to be noticed, but they remain humble without letting the claims inflate their egos.

What Pittsburghers do take seriously are their sports teams, so one of their best-loved nicknames is The City of Champions. There is rarely a home in the metropolitan area without some sort of black-and-gold jersey, flag, or banner hanging from a porch or on a wall. Jerseys are waiting to be worn to work during the home team's exceptionally exciting playoff run, when residents gather downtown for a pep rally in hopes of closing down the whole city for a full-blown victory parade when "we" win a championship.

Civic pride here comes with winning; it is as if more W's on a stat sheet somehow give the place credibility. Long after the championships have been forgotten elsewhere, Pittsburghers remember dates of World Series, Super Bowls, and Stanley Cups like their kids' birthdays and anniversaries. They remember the milestones of their lives by them. Of course, with or without a sports legacy, Pittsburgh's history gives it credibility, and its story began long before the Steelers' first Super Bowl victory in the 1970s.

So, to put things in perspective, a very brief Pittsburgh history is in order.

When prehistoric glaciers receded 16,000 years ago, the Ohio River Valley formed, providing home, shelter, and water for native peoples. Its strategic location at the confluence of three rivers made Pittsburgh a place worth fighting over. Explorers came, forts were built, and a city was born. With an abundance of natural resources, Pittsburghers began to produce things. When a growing America needed railroads and ships, Pittsburgh made the steel to build them. But industry came at a price. Steel mills meant belching smoke and fiery, pouring metal. Pittsburgh's air, water, and land suffered, as did its reputation.

By the end of World War II, city leaders recognized the need for an environmental revitalization, which continues today. By the 1980s, steel was no longer king, forcing a third of Pittsburgh's workforce

to move away. While the city changed dramatically, the perception of it did not. Outsiders still viewed Pittsburgh as a smoky, dirty city. Pittsburghers never fought the perception; they just quietly chose to rise above it. And rise they did. By diversifying the economy, Pittsburgh's community leaders focused their attention on strengths besides steel.

Manufacturing did not die in Pittsburgh when the steel mills closed. The city is still making things. The primary industries have shifted to advanced manufacturing, energy, financial and business services, health care and life sciences, and information and communications technology. Educational institutions like Carnegie Mellon University and the University of Pittsburgh, along with 34 other colleges and universities, annually pump out some of the best and the brightest. Keeping them in the city, retaining their talent, and having them as part of the region's workforce became a goal.

With strong educational infrastructure came research and development, particularly in medicine and the treatment of very sick patients. After all, it was in Pittsburgh that Jonas Salk introduced the polio vaccine in 1955. The University of Pittsburgh Medical Center (UPMC) grew to become one of the region's largest employers. Along with it came advances in cancer research and organ transplantation, and the introduction of advanced technology, like tissue engineering.

Growing from an agrarian culture into an industrial society, funded in part by a moneyed class that needed to invest in the city and its residents, Pittsburgh became a city of immigrant neighborhoods filled with hard-working people. Carnegie, Mellon, and Heinz—families that made their names through industry and the people who worked for them—created modern-day philanthropy, giving back a portion of their fortunes to the places and people that made them rich.

The character of Pittsburgh was formed, but not without its share of class struggle. The union movement has its roots firmly planted here, founded to protect workers from abuse. Still, libraries were built, arts and culture were brought to the masses, and human services were supported where government funds fell short, all to help provide a higher quality of life for the workers.

From this give-and-take of the haves and have-nots, interesting Pittsburgh characters emerged. Talented, industrious, innovative, creative people were encouraged to give it a go.

And they still are. Want to invent something? Have a cure for a debilitating disease? Can you act, sing, play, dance, write? Good at sports? Is community activity or public service in your DNA? Do you have life lessons to teach children and their parents? Are you filled with an entrepreneurial spirit? A desire to heal the sick? Have a mind for business? Think putting fries *on* your sandwich will sell more of them?

The stories of Pittsburgh residents follow the same pattern as the city's history: born and bred with traditional values mixed with a mighty work ethic and a spirit of pride in accomplishment. Many of these residents have taken that special mixture and created something legendary, beyond the norm. Pittsburgh encourages its people to dream big and gives them the raw materials and support to make those dreams come true.

That's how the legendary locals in this book came to be legendary. They embody the soul of Pittsburgh by emphasizing hard work. Only Pittsburgh, with its quirkiness, drive, and ability to rise above adversity, could have bred the mix of people you are about to meet.

Maybe it is something in the water, the air, or the soil. Whatever mystery ingredient Pittsburgh passes along to its offspring, the end result is a bunch of interesting folks with interesting ideas and good stories worth telling.

In this book, you'll see some very familiar faces alongside people whom you may have never heard of. You might spot people you know, admire, or would like to get to know more about. You'll catch yourself saying, "Really? I didn't know he was from here or she did that!" And, if you are a true Pittsburgher, you will be proud of the people in this book, but you will not boast about them. You'll be satisfied knowing you come from a place where they came from, too.

The individuals featured have a unique "Pittsburgh-ness," a character trait that comes from the marrow deep inside the city's bones. These people and their stories could only have come from or taken place in Pittsburgh, spawned by its cultural heritage, neighborhoods, schools, family ties, ethics, and character.

These are Pittsburgh's characters, but by no means is this a comprehensive list of all the legendary locals Pittsburgh has produced. For every basketball star like local legend Maurice Stokes, there are hundreds of other sports figures who could have been included. There may be only one H.J. Heinz, but

generations since his "57 Varieties" was concocted, entrepreneurs continue to create their own special sauce that helps make Pittsburgh unique.

When you finish the book, remember that there's a good chance you probably know someone featured. You could have met, or you may see, many of these legendary locals walking the streets of Pittsburgh. You could easily introduce yourself to them, and they would genuinely be interested in getting to know you, too. Some may even invite you to sit on their porch and join them in a beer or two, because it is something in their Pittsburgh character that makes them legendary. It is the stuff they are made of that makes them stand out.

There is a particular way steak is cooked in this town. It is called Pittsburgh Rare; seared and burnt to a crisp on the outside, raw and juicy in the middle. Legend has it that the original method of preparation was by searing the meat with a welding torch. Another theory is that it was common practice for steelworkers to cook a steak on a cooling piece of freshly molten metal. No matter how it came to be, Pittsburgh Rare is also a way to best describe Pittsburgh's people and its legends. All share that special Pittsburgh-ness, that tough exterior and drive to achieve, but with a genuine warmth and kindness that make them incredibly human and approachable.

Enjoy these warm, approachable legends. And think of them and Pittsburgh as rare, indeed.

—Tinsy Labrie, vice president, marketing, VisitPittsburgh

Tinsy Labrie
Tinsy Labrie is a Pittsburgh promoter with over 30 years of marketing some of the best of the 'Burgh, including the Civic Arena, Pittsburgh Spirit and Penguins, and the Pittsburgh Symphony Orchestra. She is now with VisitPittsburgh. These legendary organizations are all located within Pittsburgh and Allegheny County. As a child, Labrie dreamt of having her portrait done by Pittsburgher Andy Warhol. Through the miracle of the Warhol DIY Pop app, hers is seen here. She is honored to introduce this book of legendary Pittsburghers to those who find Pittsburgh as fascinating as she does. (Courtesy of Tinsy Labrie.)

CHAPTER ONE

Paving the Way

Pittsburgh civilization began with the Native Americans, followed by explorers who recognized early on the strategic confluence where the Allegheny and Monongahela Rivers form to meet the Ohio River. The vibrant port, which became a battleground where France and England fought for control in the 1750s, quickly experienced its first boom as a commercial city, serving early settlers following the American Revolution.

Hugh Henry Brackenridge, an early leader, played an important role in the formation of Allegheny County, and by the 1840s, Pittsburgh had grown to become one of the largest cities west of the Allegheny Mountains. Brackenridge was followed by men like Edwin Stanton, who spent time in Pittsburgh before serving as secretary of war under President Lincoln, and Thomas Mellon, patriarch of the legendary family and founder of the Mellon Bank dynasty.

Legendary locals from Pittsburgh's early days also included unknown figures, such as Margaret Schall. She was among those who persevered through dire circumstances, one of the thousands of orphans who grew up in an institutional setting, lacking a true home and without the childhood comforts others take for granted. Their own personal stories are a poignant reminder of a way of life in the years leading up to the Great Depression and an important piece of Pittsburgh's socioeconomic history that has all but vanished from documents and record books.

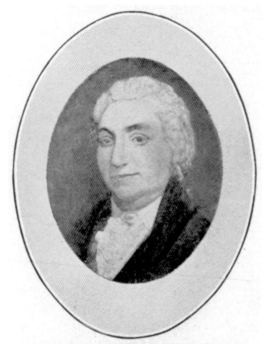

HUGH HENRY BRACKENRIDGE
Judge Supreme Court of Pennsylvania, 1799-1816
Prominent during Whiskey Insurrection. Author

Early Leader

A justice of the Pennsylvania Supreme Court, Hugh Henry Brackenridge was credited for his important role in the formation of Allegheny County. In 1786, he helped establish the first western newspaper, the *Pittsburgh Gazette*, and was elected to the Pennsylvania State Assembly. Brackenridge fought for the adoption of the federal Constitution and obtained state endowments for the establishment of Pittsburgh Academy, known today as the University of Pittsburgh. (Courtesy of Historic Pittsburgh General Text Collection.)

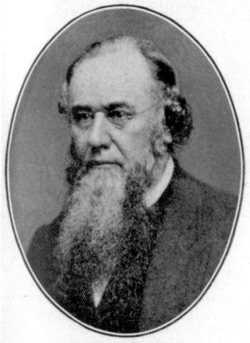

EDWIN M. STANTON
Atty. Gen'l U. S. 1860. Sec. of War 1862
Justice Sup. Ct. 1869. An intellectual giant

Intellectual Giant

Edwin Stanton lived in Pittsburgh during the 1850s and was known as a ferocious litigator and intellectual giant. He went on to serve as secretary of war in 1862 under President Lincoln. Stanton's effective management helped organize the massive military resources that guided the Union to victory. When Lincoln was assassinated in 1865, Stanton was at his bedside. Pittsburgh's neighborhood of Stanton Heights, and Stanton Avenue, bear his name. (Courtesy of Historic Pittsburgh General Text Collection.)

Banking Dynasty

Thomas A. Mellon earned a fortune as an attorney, entrepreneur, investor, and as founder of Mellon Bank, a Pittsburgh-based banking dynasty. Mellon was the son of farmers, and his family immigrated to the United States in 1818 from Ireland. As a young man, he enrolled at the Western University of Pennsylvania, spending five years and $500 on education, a large amount in the 1830s. He opened a law firm, became Allegheny County Court of Common Pleas judge, and wisely invested in real estate in Pittsburgh. Mellon opened a banking house, T. Mellon & Sons, which would become the largest banking institution in the United States outside of New York. Mellon died on his 95th birthday in 1908. Generations of the Mellon family have generously contributed to Pittsburgh's growth and welfare, also serving as trustees and advisors and as public and private benefactors. (Courtesy of the Darlington Digital Library, Special Collections, University of Pittsburgh.)

Sharing the Wealth

Henry Phipps was a childhood neighbor of Andrew Carnegie and later became his business partner at Carnegie Steel Company, a position that would make him a wealthy man as the company's second-largest shareholder. Also successful as a real estate investor, Phipps devoted a great deal of time and money to philanthropic works when he retired, believing that those who earned the greatest wealth should give back for the public good. Phipps was involved with a number of philanthropic causes, the best known being the Phipps Conservatory and Botanical Gardens, a gift to the city of Pittsburgh in 1893. He also funded the Phipps Institute for the Study, Treatment and Prevention of Tuberculosis at the University of Pennsylvania. (Photograph from the Darlington Digital Library, Special Collections, University of Pittsburgh.)

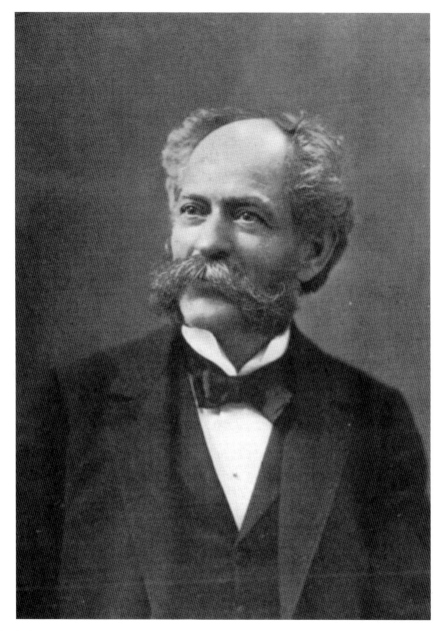

57 Varieties.

Henry John "H.J." Heinz was an early entrepreneur in 1869, selling horseradish from a horse-drawn cart and, in a stroke of foresight, using clear jars so customers could see what they were buying. He took pride in maintaining clean factories and practicing an approach of caring for his employees. By 1890, the company dramatically expanded with the construction of a factory in the North Side. H.J. Heinz was incorporated in 1905, with Heinz serving as the first president, a position he held for the rest of his life. One of the company's first products was tomato ketchup, still consistently ranked as the world's favorite. Recognized for the famous slogan "57 Varieties," the H.J. Heinz Company manufactures thousands of food products in plants on six continents and markets products in more than 200 countries and territories. (Courtesy of the Carnegie Library of Pittsburgh.)

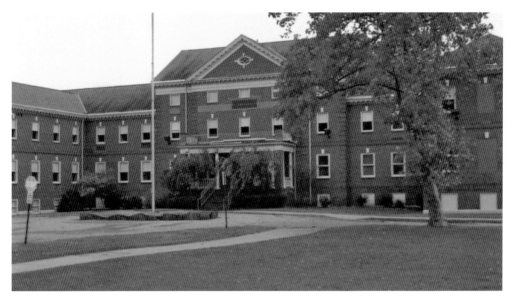

The Home.

In the early 1920s, orphanages in the United States housed more than 100,000 children, thousands of them in Pittsburgh. In 1923, a new building was constructed on Fleming Avenue by the Odd Fellows, a fraternal group providing assistance to the widows and orphans of the organization's members. The three-story, red brick Colonial home in Brighton Heights offered accommodations for 242 orphans. It was considered a state-of-the-art facility, complete with boarding accommodations, a dining hall, school, playground, barbershop, dentist office, and infirmary. For the children at "The Home," everything was communal, and privacy was nonexistent. Young boys and girls slept in an overcrowded dormitory, waited in long lines to use the lavatory, and lost their individuality to the uniform appearance of an orphan. The building still stands today, looking nearly identical to the original construction. It is part of the Pittsburgh Public School district. (Author's collection.)

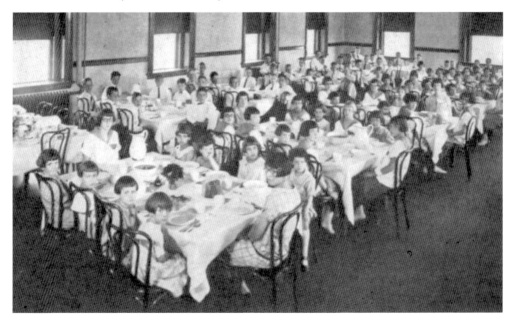

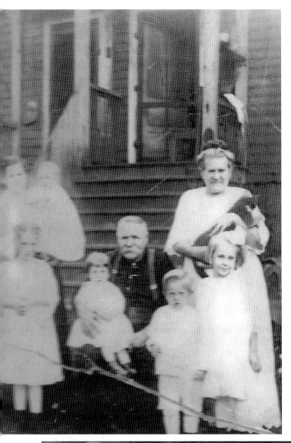

Fractured Family

Words varied in describing how children ended up in the Odd Fellows Home for Orphans. Thousands, like the youngest children of Sarah Schall, were "placed," "forsaken," "discarded" or "cast off" to The Home. Margaret Schall, pictured above at center, on her grandfather's knee, was four years old when she went to The Home along with her three-year old sister, Jane (the baby being held) and six-year-old brother, George. They arrived just three months after their father, whom they never knew, had died. Because they could fend for themselves, two older sisters were spared the same fate and were able to stay with their mother. A later photograph (below) portrays the pretense Sarah's family maintained during a holiday visit with her children, although the three youngest never lived with her. (Author's collection.)

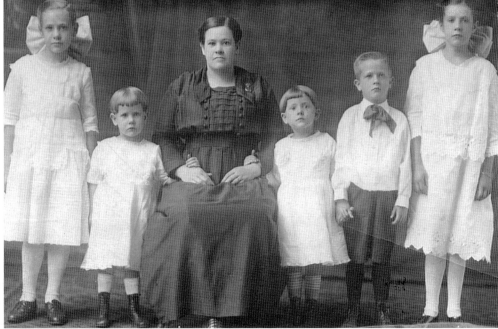

Home Kids
Thousands of children, like those in these photographs, raised in the Odd Fellows orphanage adopted the lifelong label of "Home Kid." In their own way, they became legendary locals. Their stories remain an important piece of Pittsburgh's history. This institutional setting gave orphans a place to call "Home." (Author's collection.)

Going Home
In 2011, a group of orphans and family members of orphans toured the former Odd Fellows Home on Fleming Avenue. The tour was organized by author Joann Cantrell and hosted by employees of the Pittsburgh Public School District. (Author's collection.)

Surrogate Grandparents
Charles "Chuck" and Ruth Kress became the superintendents of the Odd Fellows Home in Pittsburgh in the 1950s. They made a vocation of caring for those who had no one. Treating the forsaken orphans as if they were family and caring for them as beloved grandchildren, the couple made a lasting impression on hundreds of orphans they took under their wings, helping to put the love of God in their lives and offering the only semblance of a family that many of the young orphans would ever know. (Courtesy of Stella Neely.)

Neighborhood Barber
Known to everyone in the neighborhood, Henry Christian Hoffman, the fourth child of Lorenze and Katherine Hoffman, took up barbering at an early age. Learning from his father, he continued in the profession until he retired. At one time, he had a shop on Collins Avenue near the intersection with Penn Avenue in East Liberty. The cleanliness of the barbering profession that was instilled in him at an early age continued throughout his life. He operated the barbershop during the Depression, at times bringing home as little as $18 per week. He never owned a car and was often seen walking down Collins Avenue carrying all of his groceries. His home became a gathering place for the family for birthdays, holidays, or any excuse just to visit. In this family photograph, taken in 1886, Henry is at far left in the second row. (Courtesy of Joyce McGuirk.)

CHAPTER TWO

The Steel City

The first steel mills in Pittsburgh were built in 1875 by Scottish immigrant Andrew Carnegie. By the 1920s, half of the nation's steel came from Pittsburgh.

In his lifetime, Carnegie became the wealthiest man in the world, with one of the most impressive rags-to-riches stories. Impressions of poverty and hunger from his childhood left Carnegie with a resolve for change. In 1873, he organized Carnegie Steel, the first of his steelworks that grew into an empire thanks to the early adoption of innovations like the Bessemer process. In 1901, at the age of 66, Carnegie sold his steel company to JP Morgan, and the new company became United States Steel Corporation.

Every Pittsburgher has been connected to a legendary local from the steel industry, and past generations of steelworkers continue to be a symbol of the region's spirit and drive to succeed. Families like that of Ken Kobus had generations of grandfathers and fathers, relatives and neighbors, who worked in a mill or who engineered and fabricated machinery that could melt, cast, roll, and treat steel.

During World War II, 95 million tons of steel were produced in Pittsburgh, and the material was used for munitions, playing a vital role in the war effort until times of prosperity returned. By the 1980s, the illustrious steel mills of Pittsburgh met their demise, and the remnants of idle plants seemed to exemplify an old industry that had all but vanished.

Today, there still are more people working in the steel industry in the Pittsburgh area than in any other metro region. Today's steel industry continues to grow, proving resilient by relying on a transformation of technology that is still centered in the region. The steel industry in Pittsburgh not only remains an active part of the local economy, but is a key player in the future of the global economy.

The locals from Pittsburgh take pride in being from a steel town. Thanks to Ron Baraff and the Rivers of Steel Heritage Corporation, a proper tribute is paid to those who toiled in the furnaces that once lined the riverbanks.

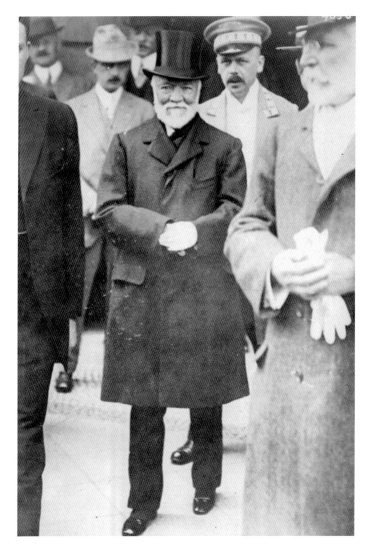

Titan of Industry

Andrew Carnegie's rags-to-riches story began in Pittsburgh with the founding of Carnegie Steel, which later became US Steel. His passion for business was surpassed by his enthusiasm for philanthropy, as libraries and museums across America, and Carnegie Mellon University, owe their existence to him. Andrew Carnegie, the son of a weaver, came to the United States in 1848 and settled in Allegheny, Pennsylvania. At the age of 13, he went to work as a bobbin boy in a cotton mill, then moved rapidly through a succession of jobs with Western Union and the Pennsylvania Railroad. In 1865, he resigned to establish his own business enterprises and organized the Carnegie Steel Company, which launched the steel industry in Pittsburgh. At the age of 66, Carnegie sold the company to J.P. Morgan for $480 million, and the new company became United States Steel Corporation. Carnegie devoted the rest of his life to his philanthropic activities and writing. He was responsible for creating seven philanthropic and educational organizations in the United States, including the Carnegie Corporation of New York, as well as a network of free public libraries to make available to the public a means of self-education. Carnegie spent over $56 million to build 2,509 libraries throughout the English-speaking world. He established the Carnegie Museums of Pittsburgh and founded the Pittsburgh Symphony Orchestra in 1895. During his lifetime, Carnegie gave away over $350 million. (Courtesy of Rivers of Steel.)

J&L

Known to its employees simply as "J&L," Jones and Laughlin, originally the American Iron Company, was founded by Bernard Lauth and B.F. Jones. Lauth's interest was bought in 1854 by James Laughlin. Located along Pittsburgh's Monongahela River, the steel company provided rival competition to the Carnegie Steel Company in the late 1800s. The firm that bore the name of Jones and Laughlin was headquartered at Third and Ross Streets in downtown Pittsburgh in 1861. (Courtesy of the Library of Congress.)

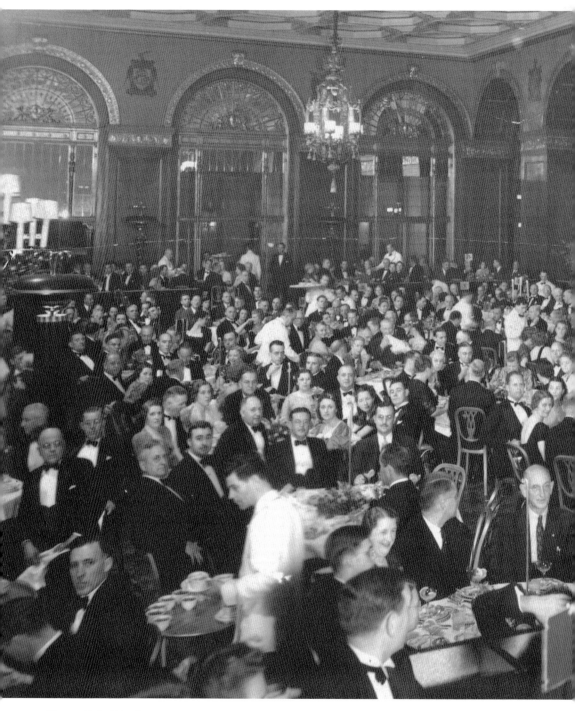

Strength in Steel
Portraying the strength of the steel industry, engineers and metallurgists packed the lobby of the William Penn Hotel in Pittsburgh in 1939 during the Association for Iron and Steel Engineers' annual conference.

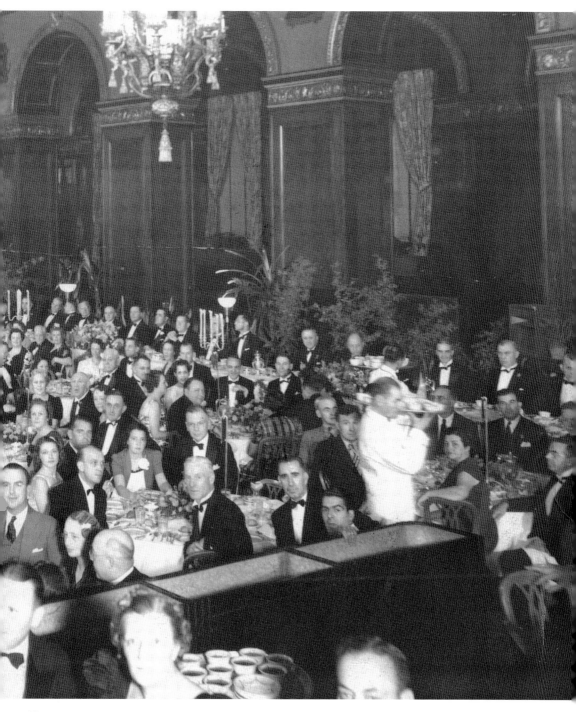

The group today, the Association for Iron & Steel Technology (AIST), has over 16,000 members from more than 70 countries and is recognized as a global leader in networking, education, and sustainability for advancing iron and steel technology. (Courtesy of the AISE archives.)

Three Generations in Steel

Ken Kobus (opposite page) came from a family of steelworkers. His maternal grandfather, Vid Salopek (pictured above with his wife, Amanda Vucic Salopek, and other Croatian immigrants) worked at the No. 1 Open Hearth Shop for Carnegie Steel from 1906 until 1953. The photograph was taken in the 1920s and shows the kind of tenement housing immigrants like Salopek lived in on Oak Street in Duquesne, where they could walk to work at the mill. Paternal grandfather Andy Kobus (pictured below with his wife) worked for 37 years at J&L Steel in Pittsburgh. Ken's father, John (shown at right on his wedding day with his wife, Helen) started working at J&L in 1937 and was followed by his son, who worked in the very same plant starting in 1966. (Courtesy of Ken Kobus.)

Steel Traditions
As a third-generation steelworker and employee of J&L Steel Co., Ken Kobus has worked closely with the Rivers of Steel Museum to preserve the heritage and tell the important story of the steelworkers, their history, and their impact on the region. Kobus is pictured at J&L Pittsburgh P-3 South Battery, adjusting what is known as a gate valve or street valve on the crossover piping to control the gas pressure leaving the coke ovens battery before going to the chemical plant. This photograph was taken in the late 1970s. (Courtesy of Ken Kobus.)

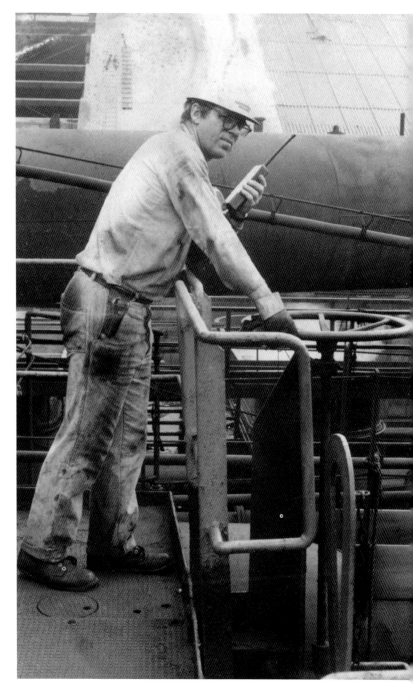

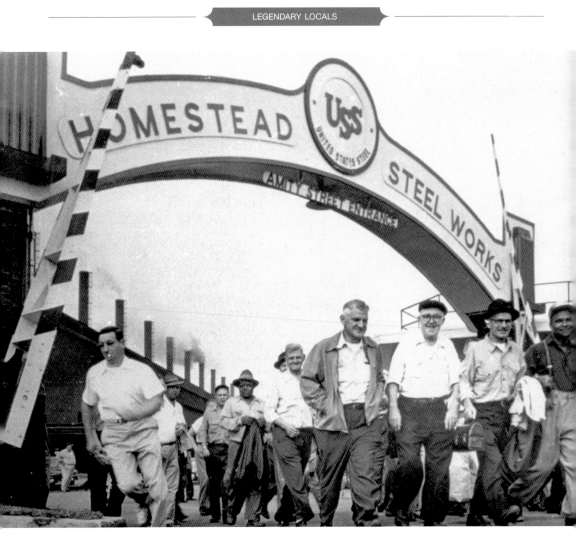

Shift Change
Everyone had a family member or friend who worked in the steel industry, and they all became legendary locals in their own right. On a typical day in the mid-1950s, steelworkers head home at the end of their shift through the Amity Street Gate at the US Steel Homestead Steel Works. (Courtesy of Rivers of Steel Corporation.)

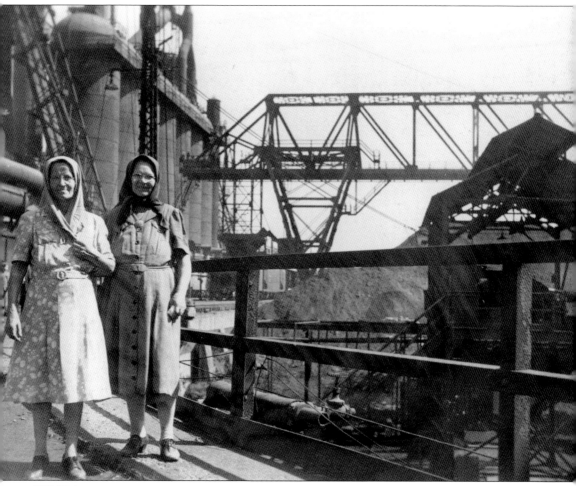

Mill Visit
Two unidentified women pose at an open house event (a very rare occurrence) at the United States Steel Homestead Works, Carrie Furnaces location in 1948. They are typical wives of steelworkers during a time when the steel mills of Pittsburgh propelled such families into middle-class status. The growth of the industry occurred through the Golden Age of steelmaking and through the 1950s and 1960s. (Courtesy of Rivers of Steel Corporation.)

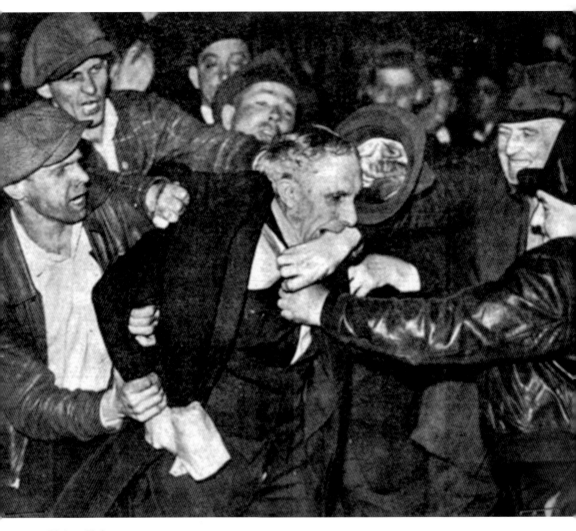

Picket Fight

C.L. Queen became a legendary steelworker when the 63-year-old (described in a local newspaper as "elderly") persisted in his attempts to get to the job he had held for 18 years as storekeeper in the Aliquippa plant of Jones & Laughlin, closed by the strike in 1937. Queen, pictured center, fought back with all his might, as is shown in the expressions on the faces of the picketers; however, he was persuaded to return home. He suffered only a black eye in the fighting. (Courtesy of Rivers of Steel Corporation.)

US Steel Home

Andrew Carnegie was 66 years old in 1901 and considering retirement. John Pierpont "J.P." Morgan, America's most important banker, envisioned an integrated steel industry that would produce greater quantities and cut costs. But this would only happen by buying out Carnegie. On March 2, 1901, United States Steel Corporation was formed, becoming the first corporation in the world with a market capitalization over $1 billion. The buyout was the largest industrial takeover in US history. The holdings were incorporated in the United States Steel Corporation, and Carnegie's steel enterprises were bought out at a figure equivalent to 12 times their annual earnings—$480 million, the largest-ever personal commercial transaction at the time.

The US Steel Tower in downtown Pittsburgh has been home to the company's headquarters since its completion in 1970. Rising 64 stories above Grant Street, the building can be seen from miles away on a clear day. (Opposite page, Courtesy of the Library of Congress; above, courtesy of United States Steel Corporation.)

Rivers of Steel

Ron Baraff is an industrial historian and director of collections and archives for Pittsburgh's Rivers of Steel National Heritage Museum. With steel as the backdrop, Baraff grew up in the Squirrel Hill and Mount Lebanon neighborhoods of Pittsburgh, hotbeds of steelworker activity. The Homestead-based organization Rivers of Steel is committed to preserving the region's industrial heritage and keeping the legacy alive with the conservation, interpretation, and development of historical, cultural, and recreational resources throughout western Pennsylvania, including the eight counties that comprise the Rivers of Steel National Heritage Area. Rivers of Steel documents the dynamic and powerful story of the region's evolution, from Colonial settlement to "Big Steel" to the modern era. The history is evident in its many artifacts, buildings, vibrant communities, and industrial sites. (Courtesy of Ron Baraff and the Rivers of Steel National Heritage Corporation.)

CHAPTER THREE

Healers, Educators, and Innovators

Whether native to the region or not, many physicians, researchers, and professors spent time in Pittsburgh, dedicating their careers to teaching, studying, and working in the medical field, leaving an indelible impact on the world. When Jonas Salk discovered the polio vaccine in 1955, the mass immunizations for children that quickly followed eventually led to the eradication of the ravaging disease.

Renowned physicians who were pioneers in their specialties, like Dr. Kenneth L. Garver, champion for disabled children, and Dr. Bob Zuberbuhler, pediatric cardiologist who treated uncounted patients throughout the decades at Children's Hospital of Pittsburgh, continued to be revered by patients and colleagues long after retirement. Dr. Anthony Silvestre, co-investigator of The Pitt Men's Study, a confidential research study of the natural history of HIV/AIDS, has lived with the faces of AIDS patients for more than 30 years. To this day, he remains in Pittsburgh and continues to find ways to work for the cause.

True to the classification of a legend, Pittsburgh's favorite neighbor, Fred Rogers, became a beloved figure throughout the world. He had a soft-spoken voice and a universal message of unconditional love. Pittsburghers had a remarkable opportunity to experience his goodness firsthand and the privilege of claiming him as their own.

Pittsburgh has been home to educators like Elmer Parks, who dedicated his life to city students. Edith Balas escaped the unimaginable horrors of the Holocaust and went on to become a respected and admired professor of art history at prestigious Carnegie Mellon University. Others were unsung heroes, like Lillian Meyers, a dedicated devotee of the Pittsburgh Compassionate Friends program. She has shown empathy and has quietly carried the heartfelt message to others that they are not alone in their grief.

Hundreds of healers, educators, and innovators with an unrelenting drive to succeed shaped the world of discovery, with beginnings in Pittsburgh.

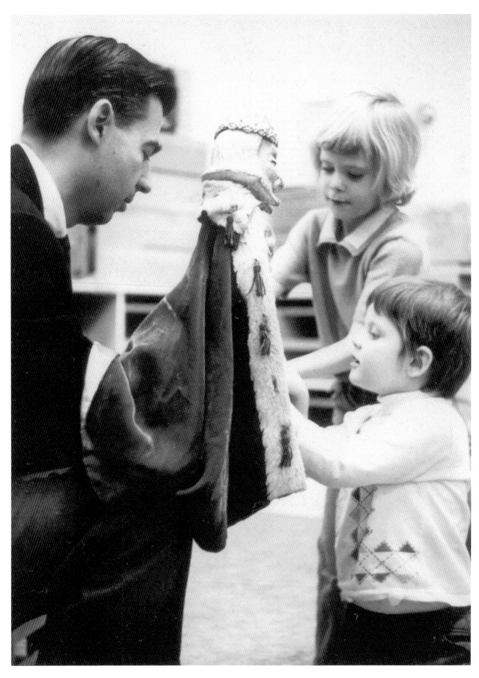

Everyone's Favorite Neighbor
Long before public television introduced him to a national audience, Fred Rogers was a graduate student in the child development program at the University of Pittsburgh and the protégé of child psychologist Dr. Margaret McFarland. Rogers was a regular visitor at the Arsenal Family Center. He is pictured here at the center with this book's author, five-year-old Joann (Bugrin) Cantrell (lower right), in 1965. He went on to become host of the popular long-running public television children's series *Mister Rogers' Neighborhood*, recorded at WQED-TV in Pittsburgh. (Author's collection.)

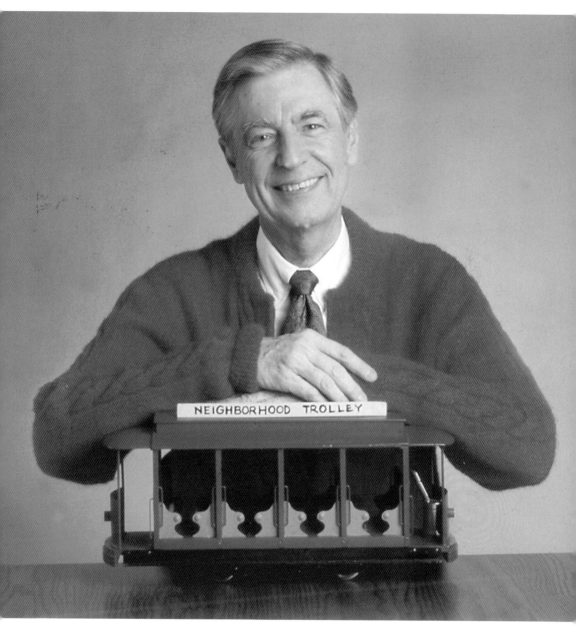

NEIGHBORHOOD TROLLEY

Dedicated to Children

Fred Rogers' mild manner, cardigan sweaters, and soft speaking voice made him a beloved figure throughout the world. Through his innate kindness and extraordinary generosity of spirit, Rogers had a philosophy that was repeated like a mantra throughout his life: "who we are and who we become as adults is a direct result of those who have taken a genuine interest in us, those who have encouraged, inspired and listened to us as children." His dedication to the education of children will remain unsurpassed, as will his universal message of unconditional love. His message, especially for the early childhood years, is that there is no substitute for a nurturing relationship. Pittsburghers had a remarkable opportunity to experience Mister Rogers' goodness firsthand and the privilege of claiming him as one of their own. (©The Fred Rogers Company, used with permission.)

Early Childhood Teacher
Nancy Curry, a former professor and director of child development at the University of Pittsburgh, introduced hundreds of children to their first experience in school and made a lasting impression as a kindergarten teacher at the Arsenal Center. Curry worked with Rogers in the 1960s, when her privileged students were fed a stream of music and ideas Rogers was experimenting with prior to his national television series. (©The Fred Rogers Company, used with permission.)

Rogers' Mentor
Child psychologist Dr. Margaret B. McFarland was the cofounder and director of the Arsenal Family and Children's Center in Lawrenceville with Dr. Benjamin Spock and Erik Erikson. She helped establish the department of child development at the University of Pittsburgh's School of Medicine in the early 1950s. Fred Rogers described her as "the most major influence in my professional life." (©The Fred Rogers Company, used with permission.)

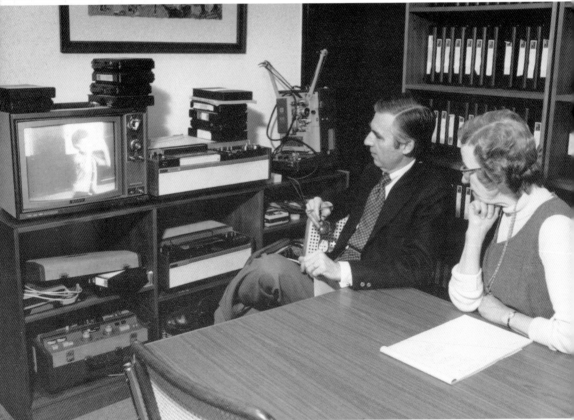

From DooWop to A+

As a young man growing up in Sharpsburg in the 1950s, Elmer Parks was probably the least likely of his friends to become not only an influential administrator for the Pittsburgh Public Schools, but someone who made a lasting impact on the students he taught and in the schools where he worked. Without much direction, there was only one thing he focused his ambitions on—becoming a doo-wop singer. In an era of young people singing on street corners and at high school dances, Parks (Right, standing second from left) and his friends formed a group called The Sequins and had aspirations of making it big with a record of their own. Only able to afford one outfit to perform in, they took extra care of the suit jackets and ties that their mothers had sewn sequins on! One night, Parks was singing, and he looked into the audience and saw his future wife, Mary Margaret. They dated for six years before marrying in 1962. Elmer Parks gained a new perspective from her that he took to heart. Knowing that he would eventually have to work for a living to support a family, he buckled down in school and decided to become a teacher. He attended Duquesne University and worked odd jobs, including as a caddy and a pinsetter at the bowling alley, to pay

for tuition. Parks grew up surrounded by bigotry, but he was committed to make changes. He became one of only three white teachers in an all-black school and worked for seven years at Lincoln School in Homewood and McKelvy School in the Hill District. He became part of the administrative team at East Hill School and was asked to be principal at Phillips Elementary School on the South Side, the lowest-achieving school in the district. As principal, he met with parents of Phillips students and made a promise that the school would become one of "Pittsburgh's finest" if a viable positive relationship could be formed with students. It took three years, but his promise held true when scores went up 45 percent in reading, 55 percent in language skills, and 32 percent in math. Basic skill scores that previously ranked below the 50th percentile drastically improved by 1986, thanks to what was dubbed "the Miracle on the South Side," a remarkable upswing that earned the school the coveted A+ designation. (Courtesy of Elmer Parks.)

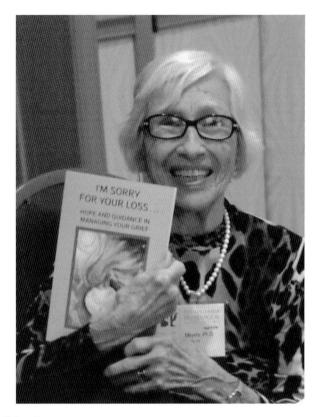

Compassionate Friend

Lillian Meyers defines compassion, which she learned firsthand from her job as a young psychology aide at a time when old and crude methods were being employed, including immersion, electro-shock and insulin shock therapies, and frontal lobotomies. She worked at the Woodville State Hospital's Farm Colony, but no one expected her to last long at the job. The very first patient she saw was naked and covered in her own waste. The patient was among 70 women, 19 to 80 years old, who were considered to be society's rejected "hopeless cases." Much to everyone's surprise, Meyers accepted the challenge, treating patients with respect and working one by one to move individuals until the Farm Colony was finally closed. Convinced that she could do more, Meyers earned a doctoral degree from the University of Pittsburgh and took a position at the Mayview Forensic Center, dealing with those considered criminally insane. She eventually became the director of treatment. Meyers was the mother of eight children. In 1981, her youngest son, Jimmy, was killed at age 17 in a car accident that changed her life. She and her husband, Bob, became involved with The Compassionate Friends, and for the past 35 years, Meyers has been in charge of the program. She carries a strong, heartfelt message to others that they are not alone and that grief never goes away completely, but it can become manageable. Meyers repeats the message that the greatest gift one can give a person who is grieving is merely to acknowledge their loss. In 1988, Meyers retired from Mayview and began consulting at The Western Psychiatric Institute as a mentor and role model. In 1989, she became the director of the Office of Education and Regional Programming. Meyers is a certified grief counselor, a fellow in thanatology (the study of death, dying, and bereavement), and the founder of the Grief Training Institute. In 2011, she received a Legacy Award from the Greater Pittsburgh Psychological Association. At 86, Meyers published her first book, *I'm Sorry for Your Loss: Hope and Guidance in Managing Your Grief,* dedicated to her son, Jimmy. Meyers speaks candidly of the continued impact on her family, offering hope and reassurance to others who have experienced a loss or to those who are trying to help a loved one with the grieving process. Dr. Meyers remains active, playing golf and tennis and attending book signings. Her energy, drive, and compassion are contagious. (Courtesy of Fran Joyce and Lillian Meyers.)

Eradicating Polio
From a laboratory at the University of Pittsburgh, medical hero Dr. Jonas Salk researched and found a polio vaccine in 1955 that began a mass immunization and, eventually, the eradication of polio, combating the disease that had caused a surge of infantile paralysis. Dr. Salk personally initiated the first inoculations to a group of 137 children at the Arsenal School in Lawrenceville. (Courtesy of University of Pittsburgh Historic Photographs, Archives Service Center, University of Pittsburgh.)

Early AIDS Research

Dr. Anthony (Tony) Silvestre is co-investigator for the Pitt Men's Study, a confidential research study funded by the National Institutes of Health that characterizes the natural history of Acquired Immunodeficiency Syndrome in gay and bisexual men. Silvestre is also a professor and director of the Pennsylvania Prevention Project, studying HIV prevention knowledge, attitudes, and access to service for people at risk of HIV infection. The Pitt Men's Study has been ongoing in Pittsburgh since 1984, with Dr. Silvestre on board since its conception. He recalls the devastation during the early years, a time when tens of thousands of young men died while experiencing stigma, shame, and discrimination. Silvestre has lived with the faces of AIDS patients for more than 30 years and, to this day, continues to find ways to keep centered while working for the cause. (Courtesy of Tony Silvestre.)

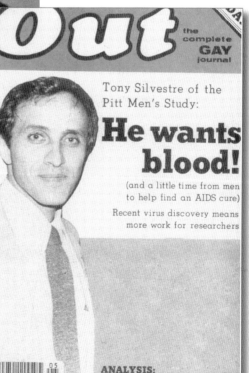

Out the complete **GAY** journal

Tony Silvestre of the Pitt Men's Study:

He wants blood!

(and a little time from men to help find an AIDS cure)

Recent virus discovery means more work for researchers

ANALYSIS:
The fundamentalist

First in Hospice

Inspired by Elisabeth Kübler-Ross's book *On Death and Dying*, Dr. Madalon Amenta dedicated her career to community nursing and was inspired to join the hospice movement in the 1970s. After serving on the hospice planning committee at Pittsburgh Hospital, she became director of education and research at Forbes Hospice in the early 1980s and was a pioneer in educating families on the importance of helping terminal patients face death with comfort upon accepting that a cure was impossible. When only a handful of hospice organizations were forming in the United States, Dr. Amenta was instrumental in making Forbes Hospice the first facility in western Pennsylvania to introduce the multidisciplinary approach to the palliative management of terminal illness. As part of the development team, she taught orientation and in-service courses for staff and volunteers on the array of individualized psychological and spiritual support offered to patients and families, including bereavement care. Dr. Amenta's work, in turn, led to founding the Pennsylvania Hospice Network. As new hospice organizations proliferated, the need for face-to-face information sharing at the program level became apparent. She called an ad hoc meeting of Pennsylvania participants at an early National Hospice Organization meeting to explore the need for a statewide association. Within a year, bylaws were officially incorporated as the Pennsylvania Hospice Network, the fourth state hospice association in the country, and Dr. Amenta (pictured below with former first lady Barbara Bush) was elected president. Later, Amenta was elected to the board of directors of the National Hospice Organization. Her illustrious career included editing its quarterly journal and being the author of the first American nursing care text for managing the terminally ill. She retired as the founding executive director of the Hospice Nurses Association, now the Hospice and Palliative Nurses Association (HPNA), in Pittsburgh. In 2011, Dr. Amenta received the HPNA's Leading the Way Award for her outstanding work as a nursing leader and for inspiring others. Her colleagues described her as one who embodied everything the award stands for, recognizing her visionary work with the HPNA and the entire palliative nursing field. She was also the recipient of the Heart of Hospice Award from the National Hospice Organization in 1998, the National Hospice Organization President's Award of Excellence, and the Yale University School of Nursing Distinguished Alumna Award in 1982, among many other honors. (Courtesy of Dr. Madalon Amenta.)

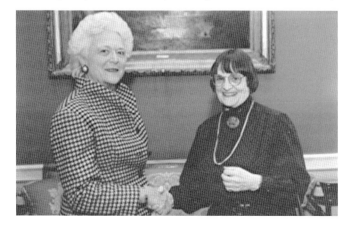

Ultimate Survivor

When Germany occupied Hungary in 1944, Edith Balas's innocent childhood immediately ended. She was deported with her family from the city of Cluj in Transylvania to Auschwitz, the Nazi death camp. Her life appeared to be doomed, as she stood naked with hundreds of women, witnessing the unimaginable horrors and the reactions of hysteria, silent weeping, and resignation. To escape the terrifying prospect of dying in the gas chamber, some committed suicide by touching the electrified wire—an image young Edith would never be able to erase. She was moved twice, and her final destination was the indescribable Bergen-Belsen camp in Germany, where dysentery and typhoid were rampant and mountains of unburied corpses lay next to the emaciated dying, indistinguishable from one another. By the time the camp was liberated in 1945, of the 15,000 Jews of Cluj, Edith's family was one of only three in which the mother, father, and one child lived. With perseverance and determination, Edith (pictured here as a young woman) endured her difficult beginning and returned to Cluj after the war. She married Egon Balas, but dreams of a new life were shattered when, in 1952, her husband fell from favor with Romania's Communist regime, was arrested, and disappeared for more than two years. Several years after his release, the couple emigrated for political reasons and settled in Pittsburgh, where both taught at Carnegie Mellon University. Egon was professor of operation research, and his book, *Will to Freedom*, explains his political past. Edith was a professor of art history for 35 years, authoring 10 books on the subject as well as curating numerous exhibitions in Pittsburgh, Budapest, Paris, and New York. Respected and held in high esteem, Edith Balas impacted thousands of students over three decades, offering "love" through teaching, encouragement, and engaging in individual conversations. Stressing the importance of building on personal interests, Balas gently persuaded her students to work, giving them hope for success through the example of her own story, as someone who endured the Nazis and Romanian Communists, and later, defeated breast cancer. (Courtesy of Edith Balas)

Passport to Freedom
Edith Balas is pictured here as she looked in 1966 on her passport from Italy. (Courtesy of Edith Balas.)

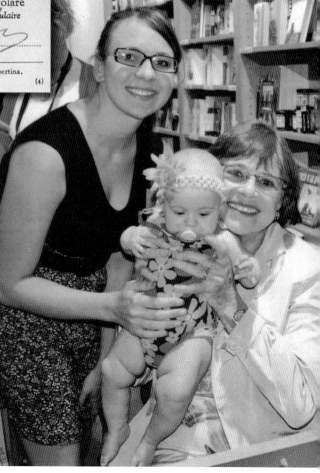

Bird in Flight
Most people who endured what Edith Balas did would be traumatized, but she chose to write a memoir, *Bird in Flight*, when she was in her 80s. Balas (seen here at a book signing) felt the need to preserve and recount the story for young people, so that they could learn the truth of the Holocaust. The book also discusses art historical problems regarding Brancusi and Michelangelo. The title was inspired by Constantin Brancusi's sculpture, as Balas considered it a symbolic depiction of her life. (Courtesy of Edith Balas.)

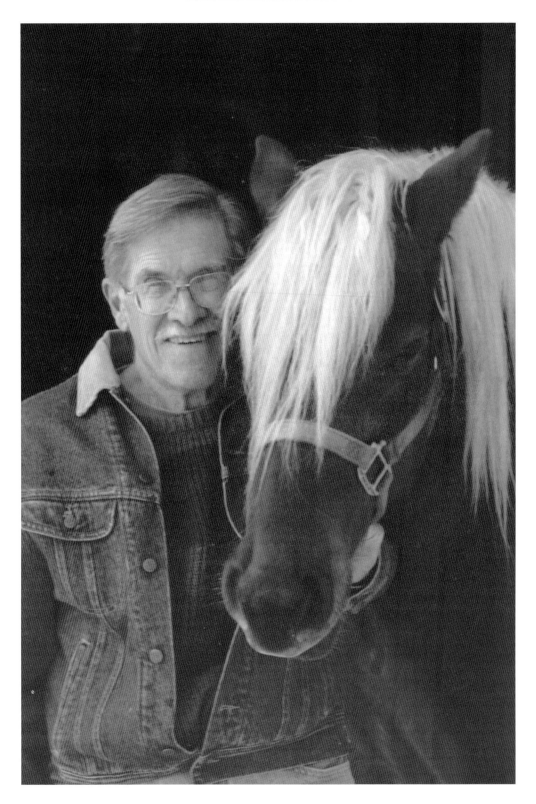

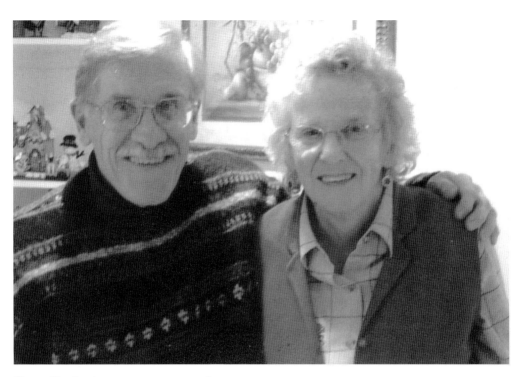

Heart Healer (ABOVE AND OPPOSITE PAGE)
Legendary cardiologist Dr. James R. "Bob" Zuberbuhler was born on the family farm in Beaver County in 1929. A graduate of Allegheny College and the University of Pennsylvania School of Medicine, his residency was interrupted for two years while he served in the US Air Force in Japan. He returned to Beaver County, set up a practice in internal medicine and adult cardiology, and worked part-time in the cardiology division of Children's Hospital of Pittsburgh. He eventually became so involved with heart problems in children that he joined mentor Dr. Richard Bauersfeld at Children's Hospital, and the two men became the only pediatric cardiologists in western Pennsylvania at the time. In the 1960s, diagnosis was based on patient history, physical examination, an EKG, a chest X-ray, and, if necessary, a cardiac catheterization. Trained to diagnose congenital defects prior to the standardization of such equipment, Zuberbuhler became a well respected expert in the diagnosis and management of children with heart disease. He authored and coauthored over 100 scientific papers as well as a textbook, *The Clinical Diagnosis of Heart Disease in Children*. As director of pediatric cardiology from 1967 to 1996, he was instrumental in the education of students, pediatric residents, and cardiology fellows. Zuberbuhler emphasized the importance of conducting a careful history and physical examination and warned against relying only on tests. He has lectured in Pittsburgh and around the world and served as acting chairman of the Department of Pediatrics and as medical director of Children's Hospital of Pittsburgh. Dr. Zuberbuhler and his wife, Janet (pictured), have four children, who grew up on the 70-acre farm where Bob and his father built a 30-foot-by-30-foot barn, which housed as many as five horses at a time. Zuberbuhler is pictured opposite with horse Nellie. Bob and Jan enjoy spending time with their 10 grandchildren and vacationing throughout the United States and around the world. Zuberbuhler led an expedition, which included a Chinese colleague and Bob's son, Jim, to the Tibet Plateau to determine the effect of altitude in congenital heart disease. The team found two particular types of congenital heart disease that became more common the higher the altitude in which a population lived. He also traveled to the Soviet Union as part of a joint USA-USSR education program on heart disease in children. When his daughter Ann asked for help to find and identify 20 species of wildflowers, a new interest awakened in Zuberbuhler. He has since described and photographed over 900 species of wildflowers, trees, mushrooms, and lichens found within a few miles of home. He has created a website, www.westernpawildflowers.com. (Courtesy of Dr. Bob Zuberbuhler.)

Humble Servant
Dr. Bruce W. Dixon, the longest-serving
director of the Allegheny County Health
Department, was nationally known for his
progressive work in the public health field
and was revered locally as the ultimate public
servant. During his 20 years as director,
beginning in 1992, Dr. Dixon dedicated his
life to a medical ministry to the poor and
those without privileges. Proud to be called
a Pittsburgher, Dr. Dixon's down-to-earth
manner, extraordinary kindness, and humility
earned him the respect of the students he
taught at the University of Pittsburgh Medical
School as well as his peers. Dr. Dixon led the
largest medical practice in Allegheny County,
a position he covered seven days a week,
often seeing patients free of charge without
anyone knowing. (Courtesy of the Allegheny
County Health Department.)

Nurse and Community Leader

Jocqueline (Jockey) DeStefano (above, center) had a commitment to the welfare of others that made a lasting impression on her friends, coworkers, and community. Raised in Homewood, she was a teenager when her father died, and took on two jobs to help her mother and four siblings. DeStefano shared her caring, loving attitude with everyone, becoming a nurse. She worked for the Visiting Nurses Association and later headed the Home Care Department at Sewickley Valley Hospital. She established the first hospital-based Meals on Wheels program in Pittsburgh and later became the hospital's liaison to Harrisburg. DeStefano was equally passionate about education and the betterment of students, spending 16 years as a member of the Pine-Richland School Board, including serving as president, as seen below at left. (Courtesy of JulieHera DeStefano.)

Gentleman and Gentle Man
A champion for disabled children, Dr. Kenneth L. Garver was often described as a gentleman and a gentle man. At right, a teen-aged Garver poses (at left) with his parents and sister. He excelled in school, and his resume quickly became packed with academic and career achievements: a scholarship to the University of Pittsburgh, where he graduated summa cum laude; an honors student during medical school; chief resident at Children's Hospital; head of pediatrics at Columbia Hospital; chief of genetics and founder of the medical genetics program at Magee Women's Hospital; and a pioneer in the prevention of spinal birth defects. (Courtesy of the Garver family.)

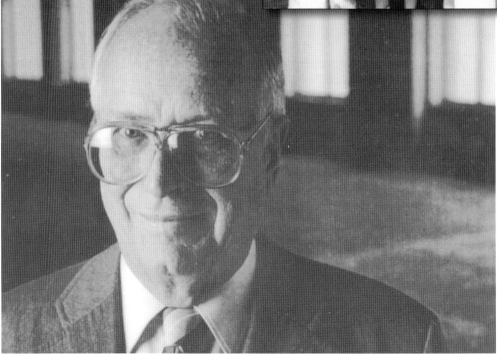

Beloved Physician

Pediatricians loved and respected Dr. Kenneth L. Garver because he was one of them. For 17 years, he practiced general pediatrics. He knew a lot about children and families; indeed, he and his wife, Bettylee, had 12 children of their own. If he got a call from a concerned mother in the middle of the night, he never hesitated to go to the home and examine the child. He treated the poor and those who were struggling without charging for his services. His concern for sick and disabled children eventually stimulated an interest in genetic diseases and birth defects. At age 43, Dr. Garver left pediatric practice and earned a doctorate from Pitt's Graduate School of Public Health. Shortly thereafter, he started the genetics program at Magee-Women's Hospital. He was one of the first advocates of nondirective genetic counseling, constantly clearing up the genetic misinformation that was so prevalent. Ken Garver was a doctor's doctor, a consummate clinician, teacher, and researcher. He had lots of memorable patients, especially a family that he encountered in the late 1950s who sparked him to become an expert in eugenics (the misuse of genetic information). These parents, survivors of Auschwitz, had lost every relative in the Holocaust, causing them to be anxious over the health of their own two children. They turned to this kindly man, their pediatrician, for reassurance. Dr. Garver regarded this family as his most unforgettable patients, saying that they changed his life. He and Bettylee later participated in a program in Israel sponsored by the National Catholic Center for Holocaust Education. Together, they published several articles on the horrors of both the Nazi and the American eugenics movements. Whenever he was asked how he was doing, Dr. Garver always replied, "I can't remember when I ever felt better." That's exactly how the small children who were his patients felt when they were with him. He died in March 2013, at nearly 90 years old. (Courtesy of the Garver family.)

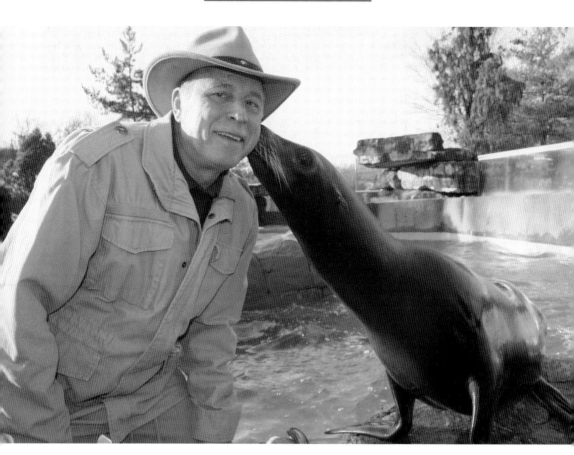

Animal Expert

Growing up in Lawrenceville, Henry Kacprzyk never realized that his love and interest in the reptile and animal world would lead to a 29-year career at the Pittsburgh Zoo & PPG Aquarium. A graduate of Penn State University with a degree in agriculture education, Kacprzyk joined the zoo in 1988 as a general keeper, working in different animal departments, including venomous reptiles. His easygoing style and extensive animal knowledge made him the perfect choice to lead tours and instruct classes for the zoo's conservation/education department. As curator of reptiles and Kids Kingdom, Kacprzyk supervises and manages staff and animals and oversees animal holding and commissary services. With his passion for reptiles, Kacprzyk has developed a diverse collection of endangered and threatened reptiles for Kids Kingdom. He serves on numerous committees and has appeared on CBS's *Early Show*, ABC's *Good Morning America*, and Animal Planet. (Courtesy of the Pittsburgh Zoo & PPG Aquarium.)

CHAPTER FOUR

Thinkers and Doers, Movers and Shakers

In addition to being designated the Steel City, Pittsburgh was also home to corporations in the coal, coke, aluminum, oil, financial, and hundreds of other industries. During the city's two Renaissance periods under Mayor David L. Lawrence in the 1940s and Mayor Richard Caliguiri in the late 1970s, skyscrapers were erected that created the dramatic city skyline, and high-profile projects signaled the city's embrace of a post-industrial future. City planning efforts shaped contemporary Pittsburgh, as the economic base eventually changed to health care, medical research, technology, and tourism, backed by ardent thinkers and doers who became the movers and shakers of the city they were committed to.

Recognized as a man of passion, Thomas "T.J." Murrin rose through the ranks at Westinghouse Electric Corp. and later led the business school at Duquesne University, where students crowded into his classroom. Later, during an economic downturn when young professionals were looking for an exit and fleeing Pittsburgh, Maddy Ross was loyal to the community in which she was raised. A true mover and shaker, Ross became legendary after being named managing editor of the *Pittsburgh Press*, making her one of the first female managing editors of a major metropolitan newspaper in the country.

When tough times and a lack of funding threatened the iconic Duquesne Incline, historic society members David and Ruth Miller rallied with Mount Washington residents to preserve the historic landmark, committed to keeping it a part of Pittsburgh's scenic landscape.

Not to be forgotten are those who were called to serve and quietly lead, like Harold McKamish, who instilled corporate responsibility in the employees of McKamish Metals and set an example as a humble man who was led by divine intervention. Equally inspired, Sister Liguori Rossner, known as the Mother Teresa of Pittsburgh, cofounded the Jubilee Soup Kitchen in 1979 in the Hill District with less than $10. She still serves as its first and only executive director.

The stories of such local legends of Pittsburgh became the stories of the city's heroes.

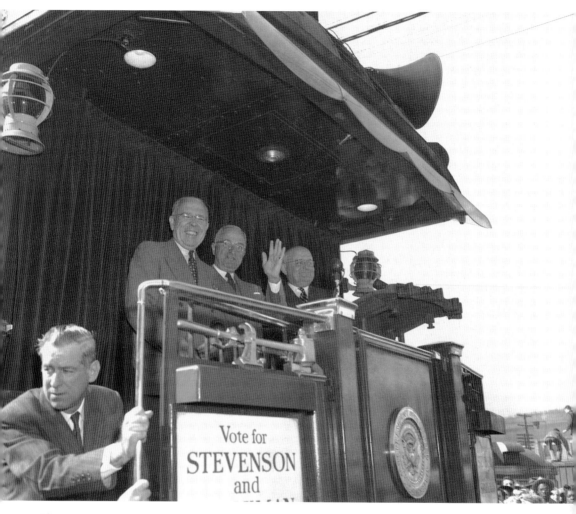

Vote for
STEVENSON
and

Most Popular Mayor
David L. Lawrence, pictured standing at left with Pres. Harry Truman, was the most popular mayor in Pittsburgh history. He was elected a record four times, serving from 1946 to 1959. Lawrence was known for forging an unprecedented partnership with the corporate community to redevelop Pittsburgh, clearing the skies of smoke, and transforming the city. He later became the first Catholic governor of Pennsylvania when he was nearly 70. (Courtesy of Paul Slantis Photograph Collection, Archives Service Center, University of Pittsburgh.)

Renaissance Man

Small in stature but larger-than-life in character and spirit, Richard Caliguiri became mayor of Pittsburgh in 1977. An administrator for the parks and recreation department, Caliguiri won a seat on the Pittsburgh City Council (shown above) before holding higher office. His visionary leadership inspired Renaissance II, the building boom that transformed downtown with high-tech firms when the steel industry was reeling. Caliguiri was mayor until his early death from amyloidosis in 1988. (Courtesy of Pittsburgh City Photographer Collection, Archives Service Center, University of Pittsburgh.)

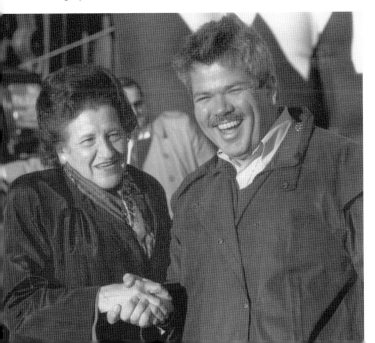

First Female Mayor

Upon the death of Mayor Richard Caliguiri, Pittsburgh City Council president Sophie Masloff (pictured with documentary maker Rick Sebak) became the city's first female mayor. (Courtesy of Rick Sebak.)

53

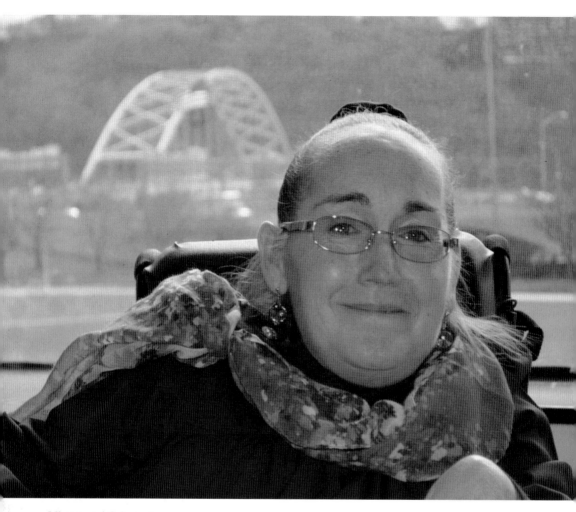

All-around Advocate

Entrepreneur, author, consultant, volunteer, mentor, and friend, Linda Dickerson works at a pace that would wear out others. With her will and intellect, Linda plows through any obstacle, wrapped in her signature cape, with her hand firmly at the power button of a wheelchair that takes her anywhere she wants to go. Alongside US attorney general Richard Thornburg, she was an advocate on behalf of the historic Americans with Disabilities Act of 1990, legislation that prohibited discrimination on the basis of disability. As a board member, Dickerson has directed nonprofit, foundation, corporate, and university governing bodies with skill and thoughtfulness. From offices overlooking Point State Park, she runs a management consulting firm, 501(c)(3)[2], challenging nonprofits to run more efficiently and successfully. Inspiring in every facet of her life, Linda Dickerson is a superhero to all and a true woman of steel. (Photograph by Junior Achievement; courtesy of Linda Dickerson.)

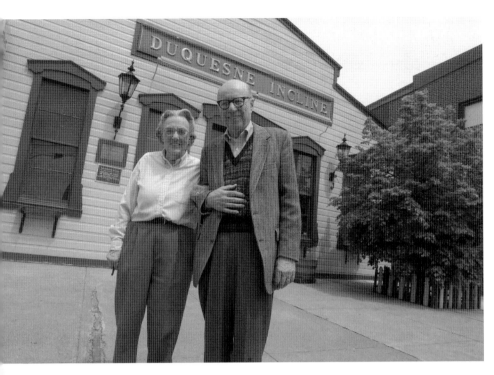

Duquesne Incline's Sentinels

As a labor of love, David and Ruth Miller dedicated their lives to the causes of the iconic Duquesne Incline, serving as president and treasurer, respectively, of The Society for the Preservation of the Duquesne Incline. The couple volunteered their time to repair and restore the 1877 cable railway, which carried more than one million riders at its peak in 1989. (Photograph by Heidi Murrin; courtesy of *Pittsburgh-Tribune Review*.)

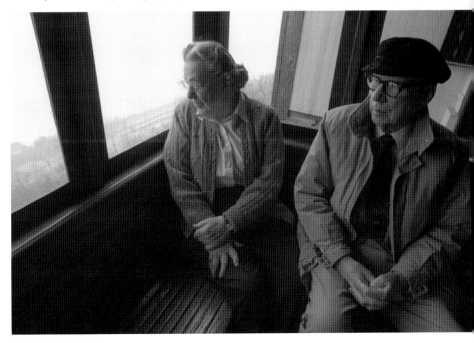

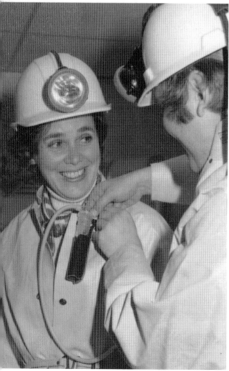

Dedicated to Mount Washington
Lifelong residents of Mount Washington, Norman and
Margaret Samways lived, worked, volunteered, and
embodied so much of what the city is about that they
epitomize genuine Pittsburghers. Born in England and
educated in London, the Samways arrived in Pittsburgh in
the 1950s and considered it their home. Dr. Norman and
his late wife, Margaret, came to Pittsburgh when Norman
answered a newspaper ad for a metallurgist at Jones &
Laughlin Steel Corp. and was offered a position working
in metallurgical development in steelmaking at J&L's
research laboratory. Margaret was well respected in the
community and had a career working for Gulf Oil Corp.
(Courtesy of Norman Samways.)

Proud to Call Pittsburgh Home

Norman and Margaret Samways settled on Mount Washington in Chatham Village, the unique neighborhood that has been likened to an authentic English village. They remained residents for nearly 50 years, proudly boasting that their neighborhood was recognized as one of "10 Great Neighborhoods in America."

Norman was associated with the steel industry for more than 40 years, and he authored over 100 technical articles. Margaret worked for Gulf Oil Corp., designing and managing environmental health and safety training and hazard education efforts in the United States and abroad. She was actively involved in the McArdle Roadway Improvement Project Task Force, seeking replacement of the barrier, fencing, sidewalk, and lighting on the city's scenic roadway. Norm was a member of Pittsburgh's first rugby football team in the 1960s and today is a dedicated volunteer at the Carnegie Museum of Natural History, in its Department of Invertebrate Paleontology. He served on the board of directors of Chatham Village and is currently on the board of the Duquesne Incline. He is a member of the National Association of Watch and Clock Collectors and is one of four people entrusted with "turning the key" to wind the clock and synchronize Pittsburgh's landmark timepiece at Pittsburgh's Children's Museum!

An optimist at heart, Norm Samways is hopeful that if young people have the opportunity to come to Pittsburgh today, they'll make the same decision that he did all those years ago. Though Samways cannot claim it as his *home*town, it is clear that Pittsburgh is certainly a town he is proud to call home. (Courtesy of Norman Samways.)

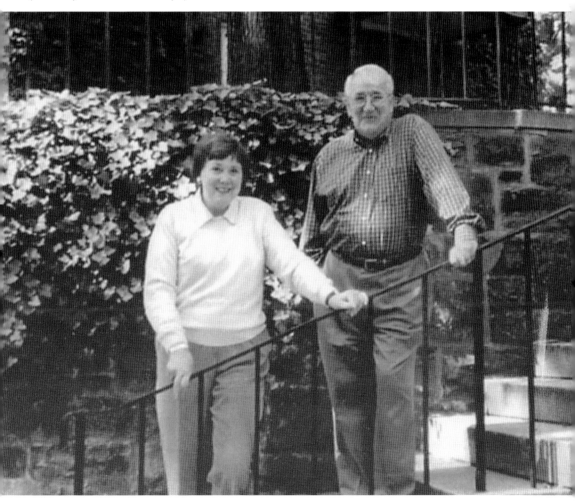

Geological Expert

Carnegie Museum geologist/paleontologist Albert Kollar has conducted more than 800 regional geology field trips, geology workshops, and seminars on historical geology as it relates to Pittsburgh for more than 30 years, reaching more than 20,000 people. As a staff member of the Carnegie Museum of Natural History in its invertebrate paleontology section, his interest in fieldwork provides the opportunity to collect rocks and fossils throughout the United States, Alaska, the Atlantic provinces of Canada, England, Wales, Germany, Sweden, and Australia. He has co-published more than 25 scientific papers on fossil brachiopods, reefs, climate change, dinosaurs, and fossil amphibians. Through his years at the museum and traveling, a lifetime process of learning about earth history and the world was enhanced. Kollar (pictured below at left with Norman and Margaret Samways at Fallingwater) served as the president of the Pittsburgh Geological Society from 2011 to 2013. The 68-year-old society disseminates geological knowledge. (Courtesy of Norman Samways.)

Whirling Dervish Activist

Larry Evans is a doer, never letting overly critical thinking get in his way. In the mid-1970s, he joined the fight for democracy in the United Steelworkers of America Union, publishing the spunky *Mill Hunk Herald* magazine during the steel shutdowns era. Pictured above sitting on the floor at left, Evans was editor of the *Bloomfield Garfield Bulletin* and founded the *Northside Chronicle* community newspaper. Evans organized creative fundraisers for progressive causes (Mill Hunk Ball, Bombs Away Boogie, Volley for Molly, Run of the Mill 10K, Roberto Clemente Sports Fests, and the Food Bank Soc-a-thons) and coordinated a cluster of Sister City youth sports and cultural exchanges with Steel City twin towns in Poland, Russia, the Czech Republic, England, Nicaragua, Puerto Rico, Bosnia, Ukraine, and Japan. Evans is pictured below at front right with a community team. (Courtesy of Larry Evans.)

Called to Care

Harold McKamish, founder of McKamish Metals (see page 78), was born in Pittsburgh in 1930, attended Penn Hills High, and married his high school sweetheart, Daisy Naley, in 1950. As a young man, he was busy making a living as a sheet-metal apprentice and taking classes at the University of Pittsburgh to advance his career and provide for his family. A turning point came when McKamish's brother-in-law was killed in Vietnam in 1968, a shattering event that provoked soul searching. McKamish knew there must be more to life than what he could feel and see. A few months later, a Billy Graham crusade came to the area, and McKamish accepted the Lord and almost immediately dedicated his life to the ministry of serving. A vocation change took him to Arizona, and a divine plan unfolded when McKamish and retired pastor Russ Bixler made a trip to San Luis, Mexico, and visited an orphanage. Upon learning that the Mexican government was about to close the orphanage, leaving 98 children on the street, an instant decision was made to step in and prevent that from happening. That event in 1986 was the catalyst for the creation of a ministry called Caring Hearts, today part of the mission department of Cornerstone Television Network. The ministry is made up of various people from all denominations who are devoted to the care of the poor and needy. Caring Hearts is responsible for an orphanage, a boys' home, a vocational school, church, Bible school, and a soup kitchen that feeds over 200 children every Saturday in San Luis. Caring Hearts welcomes anyone interested in having a life-changing experience. (Courtesy of Harold McKamish.)

Papa Harold
At left, Harold McKamish poses with a young woman and her two children. The woman grew up with her seven siblings in the San Luis Mexico Caring Hearts Orphanage. When she was getting married, she said to McKamish, "You are the only daddy I have ever known. Would you please give me away and walk me down the aisle on my wedding day?" The young people surrounding "Papa Harold" below are from the Caring Hearts Boys Home, a vocational school offering an opportunity to succeed by learning all types of trades. (Courtesy of Harold McKamish.)

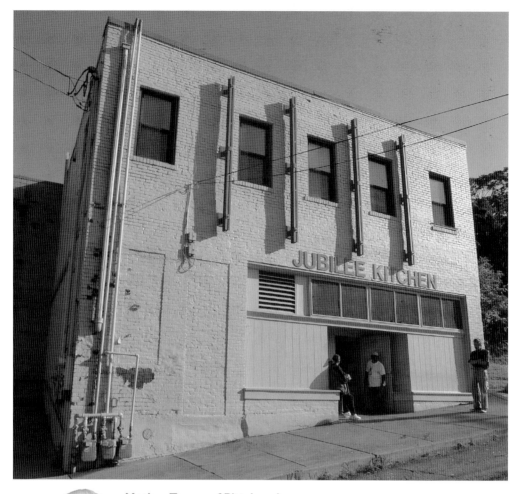

Mother Teresa of Pittsburgh

Sister Liguori Rossner has often been called the "Mother Teresa of Pittsburgh" for her care and concern for the homeless, poor, and sick. Born Patricia Rossner in 1941 in Duquesne, she learned early on about serving others. From humble beginnings, Sister Liguori cofounded the Jubilee Soup Kitchen in 1979 in the Hill District of Pittsburgh with less than $10. She still serves as its first and only executive director. Under her leadership, the kitchen has expanded from serving a hot lunch, to including a food pantry, job center, social services, day care, and outreach to mothers and young families. For more than 30 years, the community-minded and service-oriented individuals at Jubilee Kitchen have responded to the growing need to feed the poor with dignity and hospitality. (Courtesy of Stephen Henderson, www.stephenhenderson.com.)

Food Bank Founder

Joyce Rothermel (left), along with Sister Liguori Rossner, cofounded the Greater Pittsburgh Community Food Bank on the second floor of the Jubilee Soup Kitchen. This organization grew to support over 350 food pantries and soup kitchens in the tri-state area. It expanded to a $6 million warehouse in the city of Duquesne. Below, volunteers from Produce to People distribute healthy, fresh food to less-fortunate individuals and families. (Both photographs by Jason Cohn, courtesy of the Greater Pittsburgh Community Food Bank.)

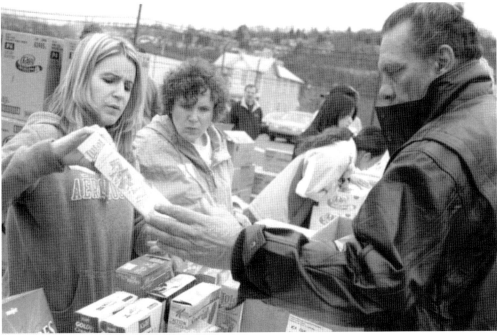

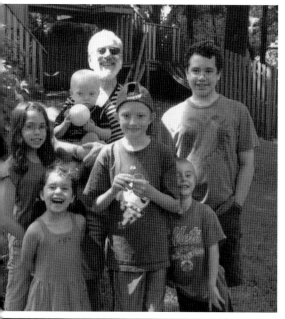

Serving Children in Allegheny County

With innovative practices and unprecedented leadership abilities, Marc Cherna changed the face of human services in Allegheny County when he became director of Allegheny County Department of Human Services. Pictured at left with his grandchildren, Cherna is credited with overhauling the county's troubled child welfare system to better protect children. His work has been recognized as a model for the rest of the country. More than a decade ago, eight children in Allegheny County died each year as a result of neglect or abuse. Today, that number is zero. Cherna has worked closely on child welfare reform with Pennsylvania Supreme Court justice Max Baer (pictured below with his wife, Beth). Both men have a passion for children and family law matters, and they have been honored with numerous awards from child welfare, humanitarian, and civic organizations and from the White House. (Courtesy of Allegheny County Department of Human Services.)

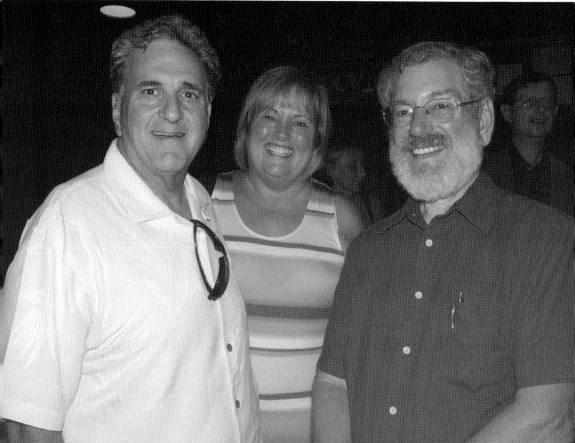

"We Need an Editor."

Madelyn Ross's first exposure to journalism came at an early age. As a high school student at Our Lady of Mercy Academy in Oakland, she recalls walking in the hallway when a nun came out of a room and said, "We need an editor in here." Young Maddy stepped in, unknowingly setting her life course. While she was an undergraduate at Indiana University of Pennsylvania, she served as editor of the student newspaper for three years. After receiving her master's degree in public and international affairs at the University of Albany, she joined the *Pittsburgh Press* as a 22-year-old reporter and discovered a talented but under-utilized staff with little motivation to change decades-old procedures. With a desire to raise the bar for the quality of journalism, she bravely proposed the idea of a weekly brown-bag writer's lunch, where reporters could discuss how to improve their writing and speak candidly about the newsroom's culture and performance. Boldly bucking the rules, the small group began talking about everything from the stories they covered to the need for an employee parking lot. The group expanded to include editors, sports reporters, mail clerks, and advertising representatives, all brainstorming how to produce better journalism. As Ross remembers, "The mood was electric, even if the typewriters weren't!" At a time when young professionals were looking for an exit and fleeing Pittsburgh, Ross was committed to the community where she was raised, energized by the sea change taking place in the newsroom. At age 34, Ross was named managing editor of the *Pittsburgh Press*, then the 12th-largest metropolitan newspaper in the nation. As one of the first female managing editors of a major newspaper, she led the newsroom to greater heights. Within four years, The *Press* staff won two Pulitzer Prizes. When an eight-month strike led to the buyout of the *Press* by the *Pittsburgh Post-Gazette*, Ross was in a unique situation in the history of journalism. While waiting for the US Justice Department to review the legality of the purchase, she served as managing editor of two competing newspapers in the same building at the same time, juggling the contrasting moods of two separate staffs. A new, combined newspaper emerged, with Ross as managing editor. The new *Post-Gazette* won nearly every journalism award given, including another Pulitzer Prize, during her editorship. In 2005, Ross found herself in a new monumental setting in Oakland, with the University of Pittsburgh, as associate vice chancellor for national media relations and the university marketing communications department, a role that allows her to use her communication skills to underscore the excellence of Pitt's academic programs and its support for the region. Now retired, Ross maintained the respect of her community and a commitment to truth, always viewing her work as a mission rather than a job. (Courtesy of Maddy Ross.)

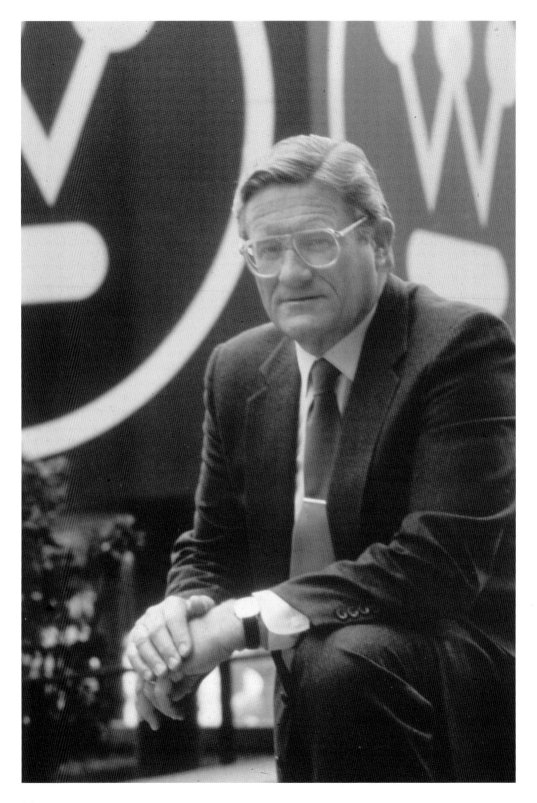

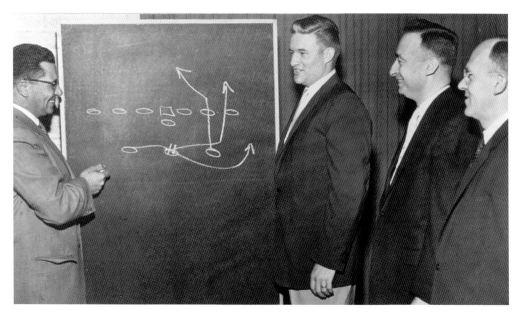

Murrin 101 (ABOVE, BELOW, AND OPPOSITE PAGE)

The son of immigrant parents, Thomas J. "T.J." Murrin (above, third from right) was raised in New York and awarded a football scholarship to Fordham, where he played under legendary coach Vince Lombardi (above left). He moved to Pittsburgh in 1951 for a job with Westinghouse Electric Corp., quickly moving to the top ranks as president of the energy and advanced technology group. Known for his sharp wit and larger-than-life personality, Murrin and his wife, Dee, raised seven children while he became a leading figure in Pittsburgh's business community. After 36 years with Westinghouse, he served as deputy US commerce secretary and as the dean of Duquesne University's business school, where he had served as chairman of the board. Murrin's unique method of teaching business courses was known as "Murrin 101." The classes were based on his corporate experiences, and the students often rearranged their schedules to crowd into his classroom. Murrin is pictured below with Pres. Ronald Reagan. (Courtesy of Heidi Murrin and family.)

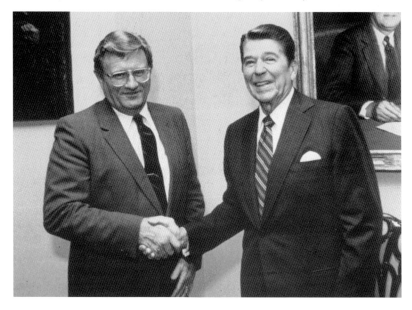

Manchester Guardians
Rev. Dr. James J. Robinson, DMin, former pastor of the Bidwell Presbyterian Church, and his wife, Betty Robinson, PhD, have lived in the Pittsburgh community of Manchester since 1962. They bought a large historic house on the corner of Pennsylvania and Manhattan Streets in 1967 during the Civil Rights Movement and, together, fought for better housing, fair employment, and better schools. The Robinsons founded the Bidwell Cultural and Training Center and the Manchester Youth Development Center (MYDC), providing a place for children to be enriched through music, art, dance, athletics, and academics. With the Manchester community, the Robinsons founded the Manchester Academic Charter School. With her expertise in child development and a long career with Pittsburgh's private and public education system, Betty founded the Training Wheels Nursery School at MYDC for three- to five-year-olds. (Courtesy of the Robinsons.)

Setting an Example

For more than 30 years, Patricia Liebman has worked to develop new and cooperative relationships between hospitals, physicians, and health insurance companies. Recently appointed COO of the new Allegheny Health Network, she will have a significant impact on health care in western Pennsylvania, focusing on improving the quality of care for thousands in the region by minimizing variations in the health care delivery process. Liebman has mentored many young people in Pittsburgh, especially women in their professional careers. The legacy of her health care work ethic will continue to contribute to the community long after she retires. Liebman, an avid runner and athlete, exemplifies living a healthy lifestyle. She has participated in the Pittsburgh Marathon and has served as honorary chair and volunteered on several boards, including Point Park University and Butler Hospital. (Courtesy of Marc Liebman.)

Angel for Women
Andrea Carelli, senior vice president and director of public relations and corporate events for PNC Bank, has managed marketing partnerships for the Steelers, Pirates, and Penguins and for nonprofits throughout western Pennsylvania. Carelli is best known as an advocate for the awareness of domestic violence and was instrumental in establishing The Angel's Fund for the Women's Center and Shelter of Greater Pittsburgh. She has served on boards including the Light of Life Mission and the Susan G. Komen Race For the Cure Pittsburgh Division. She received the Volunteerism Award from the National Association of Women Business Owners of Greater Pittsburgh and the 2011 Craig Humanitarian Award for demonstrating excellence to community service. Carelli received the 2011 Woman of Distinction in Business Award from Girl Scouts of Western Pennsylvania and, most recently, the 2012 Arthur J. Rooney Award for outstanding dedication to community service in western Pennsylvania. (Courtesy of Andrea Carelli.)

CHAPTER FIVE

Taking Care of Business

Through the centuries, Pittsburgh has opened the door of opportunity for many men, women, and families. This entrepreneurial spirit and sense of business adventure are still thriving today—not just locally, but worldwide. Businesses like Robert Wholey & Co. and Reed & Witting have endured over generations, serving the people of Pittsburgh from its earliest days. Small-business owners have played just as important a role in the economy as the major corporations headquartered in the Golden Triangle.

For residents of Pittsburgh, the names Gus and Yia Yia have become synonymous with childhood and summertime. The business owned by Gus and Stella Kalaris is recognized by the famous orange cart parked on the North Side that has been selling hand-shaved ice balls since 1934, or, as the slogan says, "since your Dad was a lad!" In the true spirit of small-business owners, Gus and Yia Yia have provided generations of young children, grown children, parents, grandparents, and friends from every neighborhood in Pittsburgh with happy memories—and the prices haven't changed much, either!

When one door closes, another one opens. So it was with the closing of St. John the Baptist Church in 1993, leaving Lawrenceville parishioners heartbroken. In a few years, Pittsburgh native and entrepreneur Sean Casey stepped up to the plate, renovating and revitalizing the community's parish, converting it to The Church Brew Works. Although it took some time to get used to having a beer in a church, the appreciation of having the building adapted and reused to preserve history overrode the sentiment. Crowned the "Best Large Brewpub in America," the Church Brew Works is a prime example of reinvention and of a Pittsburgh entrepreneurial success story.

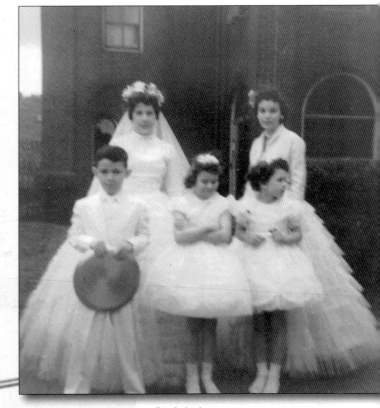

St. John's
Founded in 1878, St. John the Baptist Catholic Church served the community of Lawrenceville, expanding until the early 1900s. By the late 1950s, the school and church were thriving; the annual May Crowning was one of the largest, most anticipated events of the year. In the second row above are May Queen Peggy Bell (left), and Joanne Traub. The parish survived a fire, flooding, and the Depression, but when steel mills started to close and the Lawrenceville population declined, St. John's began to lose members. Due to financial circumstances, the Diocese of Pittsburgh restructured the churches in its jurisdiction in 1993 and St. John the Baptist was closed. The building was under-utilized for three years until its redevelopment and conversion as The Church Brew Works, which opened for business on August 1, 1996. (Courtesy of Vera Traub and author's collection.)

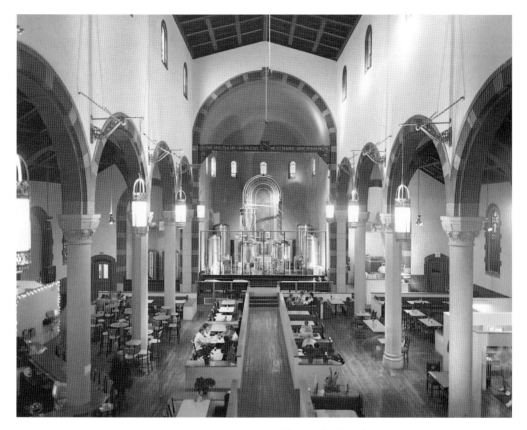

Heavenly Beer!
Sean Casey (left) is the founder and owner of The Church Brew Works, a microbrewery and restaurant renovated from the shuttered St. John the Baptist Church and opened in 1996. The Church Brew Works was one of the first participants in the revitalization of the historic community, receiving the Award of Merit from the History and Landmarks Foundation for the adaptive reuse of the property. The establishment's beers have won gold, silver, and bronze medals at the Great American Beer Festival and World Beer Championships, and the company has been featured in *Nation's Restaurant News, Brewpub* magazine, *National Geographic Traveler* magazine, *Conde Nast,* the *Washington Post, INC.* magazine, and on the Food Network, CNN, *The Today Show*, and *USA Today*. In October 2012, The Church Brew Works was crowned Best Large Brewpub in America at the prestigious Great American Beer Festival, taking home four medals in four categories and winning the second-most medals of all 666 participating breweries. (Courtesy of The Church Brew Works.)

73

100 Years of the Finest

For more than 100 years, Robert Wholey & Co. fish market has been a Pittsburgh tradition. Founded in 1912 in McKees Rocks, the store was opened by Robert L. Wholey and sold live poultry, meats, sausages, and coffees. With an entrepreneurial spirit that would be evident for the rest of his life, son Robert C. established the Robert Wholey Company Poultry Market in Pittsburgh's Market Square. In 1959, the business moved to its present location at 1711 Penn Avenue in the Strip District. In 1960, fresh fish and seafood was added to the already lucrative business, and soon, the company began importing seafood from all over the United States and around the world. The company continued to expand, becoming an international operation. Today, Jim Wholey and his three brothers are the third generation running the business. The family credits "the Pittsburgh work ethic" passed down from their father and the loving support of their mother, Lois, as the reasons the family business has survived and prospered for more than a century. (Photograph by Eva Linn; courtesy of the Wholey family.)

Pittsburgh's Favorite Bakery

When Italian immigrant James Mancini opened a one-room bakery in McKees Rocks in 1926, he began experimenting with his own formula, and Mancini Bread was born. He started by baking 100 loaves each night, then delivering the fresh bread to his customers the next morning, with the "twist" loaf as his signature. After World War II, brother Ernie joined him, and the two enjoyed a successful partnership until 1971, when Jim retired and Ernie's son, Frankie, developed Mancini's famous raisin bread recipe. Today, keeping the family tradition, Ernie's daughter, Mary Mancini Hartner, is owner and operator of Mancini's, baking more than 10,000 loaves a day. She utilizes the same old-world techniques that her Uncle Jim practiced in 1926. Consistently voted the best bread in Pittsburgh, Mancini's employs 48 people and operates 24 hours a day, seven days a week. (Photograph by Vic Kahn; courtesy of Mancini's Bakery.)

Since Your Dad Was a Lad

If you are fortunate enough to live in Pittsburgh, or if you have spent any time visiting, the names Gus and Yia Yia have become synonymous with childhood and summertime. The business owned by Gus and Stella "Yia Yia" Kalaris (seen in the photograph on the left) is known by its famous bright orange cart with the umbrella, parked on the North Side. Gus took over the business from his father when he was 18 and has been selling hand-shaved ice balls since 1934, or, as the slogan says, "since your Dad was a lad!" In the true spirit of small-business owners, Gus and Yia Yia have provided generations of young children (like Madi Moffat, below), grown children, parents, grandparents and friends from every neighborhood in Pittsburgh with happy memories. The prices have remained much the same. The cart can be found each day from about 11:00 a.m. to 9:30 p.m., May through November. (Courtesy of Gus Kalaris and Scott Moffat.)

Longtime Bar Owner

Paul Nied (pictured at right and below) carried the spirit of supporting others throughout his life, crediting his time spent on European battlefields during World War II as an experience that enriched his attitude. Raised in Homestead, he received his degree from Duquesne University and entered the Army. He returned home in 1946, joining his father, Ted, at the family bar known as Nied's Hotel, at 5438 Butler Street in Lawrenceville. From its grand opening on August 31, 1941, until 2012, Nied's was under Paul's watch. Fellow GIs and other customers who frequented the bar considered him a loyal friend, knowing he was there in times of need, often covering for those short on cash until payday. Nied's son, Jim, followed in his father's footsteps, continuing the tradition of providing food and hospitality to Pittsburgh patrons. (Courtesy of Jim Nied.)

Nobody Cares for Eyes More than Pearle
Twin brothers Merle (left) and Stanley "Buddy" (center) Pearle are shown at a Pittsburgh Pirates spring training game with their brother, Lester (right). They were born in the Hill District of Pittsburgh, and the twins became successful optometrists. Merle kept a small family practice in Ebensburg, Cambria County, and Buddy created Pearle Vision, a new type of shopping experience that revolutionized the way Americans purchased prescription eyeglasses. Pearle Vision became the world's largest network of optical retail outlets and branded itself with the slogan "Nobody Cares for Eyes More than Pearle." (Courtesy of the Pearle family.)

Committed to Responsibility
Located in Lawrenceville, McKamish Inc. is a sheet-metal contractor with a long legacy of charitable giving. Founded in 1975 as McKamish Metals under the leadership of Harold McKamish, McKamish Inc. services the mechanical contracting needs of projects as diverse as banks, steel mills, manufacturing facilities, hospitals, data centers, and retail buildings. The staff at McKamish works with architects, engineers, developers, and contractors to deliver the highest-quality product and takes pride in their commitment to acting responsibly in the Pittsburgh communities. The company makes it a priority to donate staff time and millions of dollars to worthwhile causes. (Courtesy of McKamish Inc.)

Passion and Precision in Printing

Reed & Witting Company is one of the oldest printers in the tri-state area. When printer Edward P. Cyphers (above right in 1928), engraver Leonard L. Witting, and book binder Thomas M. Reed came together to form a company in 1900, the business printed books, engraved stationery, and produced pen ruling for ledgers. Today, 113 years and four generations later, Reed & Witting Co. is proud that its dedication to quality and customer service has endured, remaining unsurpassed as it continues to serve longtime and new customers in Pittsburgh. From its present location at 2900 Sassafras Way in the Strip District, Reed & Witting sets the bar with the latest technology in print and quality control. Designated as a G-7 Master Printer, the company is ISO-compliant and is certified by the Forest Stewardship Council to meet the sustainability needs of its clients. Pictured below in 2008 are, from left to right, (first row) Edward J. Cyphers and E.J. Cyphers; (second row) Dan Ray, Brian Lawton, and Dave Cyphers. These photographs were taken 80 years apart. (Courtesy of David Cyphers.)

CHAPTER SIX

Within the City of Champions

With bragging rights to six Super Bowl championships, five World Series titles, and three Stanley Cups, the city of Pittsburgh prides itself on the great performances of its sports teams as faithful followers of the Steelers, Pirates, and Penguins. Pittsburgh earned the nickname "City of Champions" in 1979, when the Steelers beat the Dallas Cowboys for their third Super Bowl title and the Pirates won the World Series against the Baltimore Orioles in seven games later that year. The repeat of winning more than one title in the same year happened again in 2009, when the Steelers and Penguins were crowned champions. Yet a city's designation of being a sports town relies not only on winning, but on the strength of its fan base, including dedication to the local high school, college, and university teams as well. In the early days of the City of Champions, legendary baseball slugger Josh Gibson (known as "the Black Babe Ruth" by many) knocked home runs out of the park, and Chuck Cooper made history as the first African American to be drafted into the NBA. Remarkable sports heroes like Charlie Batch and North Catholic High School basketball coach Don Graham are admired and remembered not only for athletic accomplishments, but as mentors who gave back to their community by teaching important life lessons and making a lasting impact on hundreds of youth. "Steeler Nation" extends beyond the city limits; Terrible Towels wave proudly from east to west and north to south. Pittsburghers, no matter where they are, will continue to cheer for their heroes and teams.

Baseball Slugger
A hero in the Negro Baseball Leagues, Josh Gibson (pictured here with some of his biggest local fans) was born in 1911 in Georgia and later moved to Pittsburgh's North Side. Gibson played for the Homestead Grays and the Pittsburgh Crawfords in the 1930s and until 1946, batting a phenomenal .461 his rookie year.

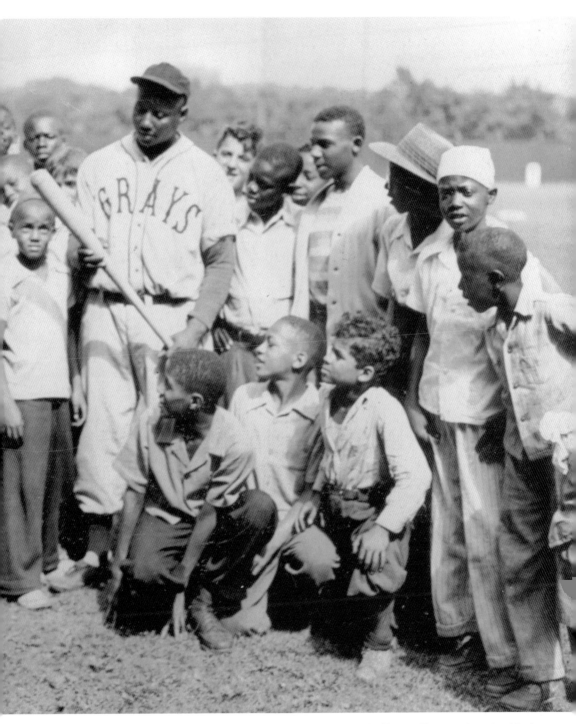

Gibson was key in the Grays' win over New York's Lincoln Giants in the Eastern Division championship. In Yankee Stadium, he slammed a home run that traveled more than 500 feet. Gibson, known as "the Black Babe Ruth," went on to play on nine East-West All-Star squads and was ranked second only to Satchel Paige as the most popular player in the Negro Leagues. (Courtesy of Luminary Group LLC.)

The Pittsburgh Kid (OPPOSITE PAGE)
Local boxing hero and the oldest of five children, William David Conn, better known as Billy Conn, was born to a Westinghouse millworker and left school during the Depression to box for prize money. Never an amateur, the feisty youth who became "The Pittsburgh Kid" was the light heavyweight champion and took on Joe Louis in 1941 in an unforgettable match for the heavyweight title. Conn married Mary Louise Smith, also from Pittsburgh. The couple is pictured at left. In 1998, on the 57th anniversary of the Pittsburgh boxer's 1941 heavyweight title, Mayor Tom Murphy and the City of Pittsburgh named the corner of Fifth Avenue and Craig Street Billy Conn Boulevard (below). (Courtesy of Tim Conn and family.)

First in NBA

Pittsburgh native and Duquesne University player Chuck Cooper Jr. "went through hell" to become the first African American drafted in the NBA, by the Boston Celtics. This occurred only three years after Jackie Robinson integrated Major League Baseball. When Cooper emerged from his professional basketball career, he followed advice to attend graduate school, earning a master's in social work from the University of Minnesota in 1961. He then began a life of public service. Cooper became the first recreation director for the City of Pittsburgh and, later, an urban affairs officer with PNC, leading many affirmative action and community development programs. (Courtesy of the Chuck Cooper Foundation.)

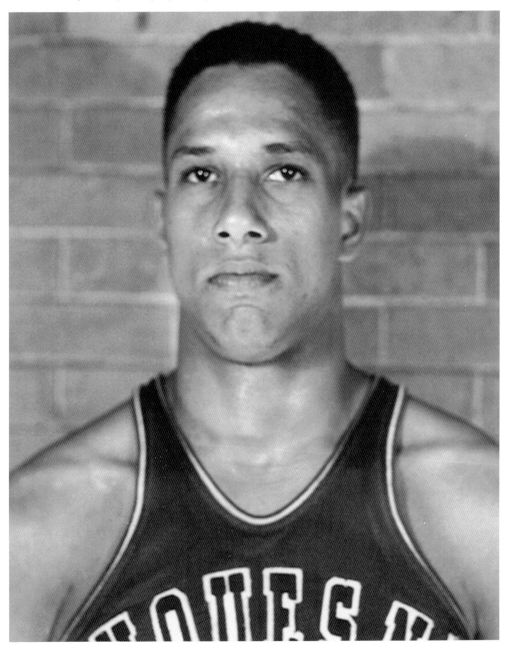

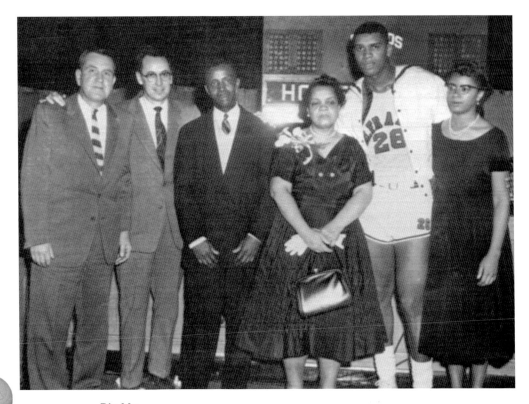

Big Mo

Since his premature death in 1970, the likes of Maurice Stokes have not been seen. Stokes had a combination of strength, speed, and size that has gone unmatched. Born on June 17, 1933, in Rankin, just outside Pittsburgh, Stokes played for Westinghouse High School and was offered 10 basketball scholarships before attending St. Francis College in Loretto. Standing six feet, seven inches tall and weighing 232 pounds, he went on to play for the Rochester/Cincinnati Royals, with high expectations of changing the game of basketball. His career ended on the last game of the 1958 season, when Stokes hit his head on the floor while driving to the basket. He later suffered a seizure and post-traumatic encephalopathy, and then fell into a coma. When he woke, Stokes was permanently paralyzed. He lived for 12 more years. Pictured above are, from left to right, Willard Fisher (Westinghouse High School coach), Dr. William T. "Skip" Hughes (St. Francis head coach), Tero Stokes (father), Myrtle Stokes (mother), Maurice Stokes, and his twin sister, Claurice Stokes. (Courtesy of Saint Francis University Athletics.)

Clemente Museum (ABOVE AND OPPOSITE PAGE)
Ultimate baseball fan Duane Rieder (above) has dedicated most of his adult life to honoring the memory of Pittsburgh Pirate Roberto Clemente (opposite page). Known as a great humanitarian who worked quietly, Clemente was killed in a plane crash at the age of 38 while on a mission to take relief supplies to survivors of an earthquake in Nicaragua. Rieder never forgot his hero, and in 2006, he opened The Roberto Clemente Museum at 3339 Penn Avenue in Doughboy Square. The museum, a labor of love for Rieder, is housed in a former firehouse in Lawrenceville. Rieder spent an immeasurable amount of time and investment to create the two-story, 4,400-square-foot shrine to Clemente, proudly displaying memorabilia from the legendary hero's life and career. The museum notes that Clemente became the 11th player in baseball history to record 3,000 hits and that he had a .318 lifetime batting average, but it also honors his humble and private humanitarian work, which continues to be recognized long after his death. The museum contains the bats and balls, mitts, uniforms, and photographs from the Clemente family collection, along with two of his twelve Gold Glove trophies and the 1961 Silver Bat that Clemente received as National League batting champion. (Courtesy of Duane Rieder.)

Team Player

The trivia question "Who played for both the Pirates and the Penguins?" may stump some, but most Pittsburghers know the answer: Vince Laschied, beloved icon best known for playing the organ for the Pittsburgh Pirates from 1960 to 2009 and for the Pittsburgh Penguins from 1970 to 2003. For more than four decades, Laschied's wit at the keyboard entertained generations of sports fans. He was honored

90

by being inducted into the Penguins Hall of Fame in 2003, most likely the only organist in a professional sports hall of fame. Laschied is pictured with Chase Edmonson (standing), who was directing game night activities during the first Stanley Cup playoff game ever held at the Civic Arena, in May 1991. (Courtesy of the Laschied family and Chase Edmonson.)

Winningest Coach

Those who follow Pennsylvania high school boys' basketball know legendary Don Graham is the state's winningest coach. He guided North Catholic from 1948 to 1999. The family man who set an example as a husband, father, and grandfather was not only a coach but a trusted mentor, role model, and friend to players, students, and coaches for more than half a century. In Graham's 51-year career, his teams won 801 games, setting the state record for wins in January 1996. Under his direction, North Catholic won three state Catholic championships, numerous league titles, and 10 Western Pennsylvania Interscholastic Athletic League section titles. A teacher first, his most important statistic was that more than 90 percent of his players received college degrees. He used sports to teach players to accept responsibility and to deal with adversity, giving them life lessons that they could not get in a classroom. Graham is pictured above seated at front row center in the light colored jacket during the 1996 McDonald's All American Game, one of the most prestigious high school all-star games, when it was played in Pittsburgh. The game is nationally televised and that year, the featured high school player was Kobe Bryant. (Courtesy of the Graham family.)

First Family of Hoops

Tom and Suzie McConnell of Brookline are the proud parents of a family of hoopsters who have been on the basketball courts for decades. Daughter Suzie McConnell-Serio became a local legend when she won a gold medal with the 1988 US Olympic women's basketball team, and she later played for the Cleveland Rockers. Her name has become synonymous with women's basketball, as she coached Oakland Catholic High School, Duquesne University, and now the University of Pittsburgh's women's teams. The McConnell family has become permanent basketball fans, well known on the courts throughout the decades, with six McConnells attending college on basketball scholarships and three coaching at the college level. Pictured here are, from left to right, Tim, Kathy, Tom Jr., Suzie, father Tom Sr. and mother Sue, Maureen, Eileen, Patty, and Michael. (Courtesy of the McConnell family.)

More than a Quarterback (ABOVE AND OPPOSITE PAGE)

Charles D'Donte "Charlie" Batch was born in humble circumstances in the steel-mill community of Homestead, across the Monongahela River in Pittsburgh. The eldest of Lynn Settles' three children, Charlie started football with the Steel Valley Midget Association when he was seven. He played at Steel Valley High School, where he lettered in both football and basketball and continued to keep the academic grades required to play. Charlie played college football at Eastern Michigan University, where he set numerous school and Mid-American Conference records.

In 1998, Charlie was chosen in the second round of the NFL draft by the Detroit Lions, where he spent the first four seasons of his professional career as the starting quarterback. In 2002, he returned to his hometown as a member of the Pittsburgh Steelers. He earned two championships, in Super Bowls XL (2006) and XLIII (2009).

More than his athletic accomplishments, Batch's life was defined in his junior year at Eastern Michigan, when he received a devastating phone call from his mother with news that his sister Danyl had been killed. She was an innocent victim of gunfire between rival gangs. Batch focused his grief on a mission to spare others from experiencing this loss and anguish. Through the Best of the Batch Foundation, established in 1999, the memory of his sister lives on as the organization serves underprivileged youth. Batch takes a very active, hands-on role, regularly visiting schools in the Steel Valley District and around the Pittsburgh region to speak with students of all grades. Batch graduated from Eastern Michigan University in 1997 with a bachelor's degree in criminal justice, but his commitment to education continues. Through the NFL Business Management and Entrepreneurial Program, Charlie has completed programs at the Wharton Business School in 2009, Harvard Business School in 2010, and Kellogg School of Management in 2012. (Courtesy of The Batch Foundation.)

94

Pirates and Prader-Willi Syndrome
The city of Pittsburgh got a two-for-one deal when Clint Hurdle took the position as Pirates manager in 2010. Hurdle's daughter, Madison, was born in 2002 with Prader-Willi syndrome, a chromosomal disorder affecting one in every 12,000 children, causing low muscle tone, short stature, and life-threatening obesity if not treated. Moving to Pittsburgh to manage a major-league team, Hurdle was reassured knowing that the renowned Pittsburgh Children's Institute, one of the foremost providers of care for the genetic disorder, could offer the best care and treatment for his daughter. Since then, he has become the national spokesman for the Prader-Willi Syndrome Association, drawing public awareness to the struggles families face in dealing with their children's conditions. Hurdle is shown here with Kacee Turner. (Courtesy of the Pittsburgh Pirates and The Children's Institute of Pittsburgh.)

CHAPTER SEVEN

Pittsburgh *Is* Art

The famous advertising executive Leo Burnett once said, "Curiosity about life in all of its aspects is still the secret of great creative people." Innate curiosity is the stuff that built the arts community in Pittsburgh.

The freedom to dream, combined with the tools to learn and the encouragement to create, has inspired Pittsburgh's journalists, photographers, filmmakers, musicians, and dancers for decades. Considered an economic engine, the arts are a major reason why Pittsburgh is repeatedly recognized as one of the most livable cities for families and businesses.

Dancer Gene Kelly, artist Andy Warhol, and playwright August Wilson have pulled Pittsburgh artists into the limelight, with hundreds of notable others preceding and following them. It would be rare to find a Pittsburgher who has never heard of Rick Sebak, local producer and documentary maker, whose smile and distinctive voice are instantly recognizable. Sebak tells the stories of every place and every particular thing that make Pittsburgh so beloved. Legendaries Joe Negri and Roger Humphries are jazz musicians who made mindful decisions to stay in Pittsburgh, despite the temptation of making it big in larger cities. They chose to share their talents in the community they called home. Pulitzer Prize–winning author David McCullough was raised and educated in Pittsburgh and went on to become a nationally recognized writer and historian. He has never forgotten his roots, however. The native son is so revered in his hometown that the city's Sixteenth Street Bridge was renamed for him on July 7, 2013, his 80th birthday.

These individuals are a mere introduction to the art culture that has proudly endured in the Three Rivers community. Visit the museums in Oakland or the North Shore or spend an evening at a theater or a local club in the downtown cultural district, and it becomes clear that the arts are alive and well and continue to flourish in Pittsburgh!

Journey to Normal (ABOVE AND OPPOSITE PAGE)
The course of filmmaker JulieHera DeStefano's life changed on a walk. She (at left holding flag) and her mother, Jocqueline DeStefano (right, and page 47), took part in the 2010 Pennsylvania Hero Walk, a 342-mile trek from Philadelphia to Pittsburgh. As they walked across the state with veterans and supporters of the Wounded Warrior Project, DeStefano's intended purpose became clear: the making of *Journey to Normal: Women of War Come Home*. At the suggestion and with the support of Lt. Col. Thomas Stokes (US Army Reserves), DeStefano spent three months in 2010–2011 touring Afghanistan (as pictured opposite) interviewing 100 female veterans as they prepared for the end of their deployments. She gained perspective on the social, emotional, and psychological challenges of returning home, an experience most civilians never have the opportunity to witness. A Carnegie Mellon University School of Drama graduate, DeStefano produced and directed *Journey to Normal* as a documentary exploring the social dynamics of women who have served in Iraq and Afghanistan. The film preserves their stories and follows their reintegration into civilian life. The true storytellers are the women themselves, and their narratives shed light on the gap between military and civilian culture. The film cultivates a network that connects veterans to one another and educates them about the professional services available to them. Following the lifelong loving example of compassion and support set by Jocqueline as a role model, DeStefano believes that her mom, who died in September 2012, is still guiding the project. *Journey to Normal* will debut at film festivals in 2014, with the hope that it will move to theaters nationwide. (Courtesy of JulieHera DeStefano.)

Courier Veteran

Pittsburgh native Rod Doss (pictured at center, above, with Pres. Barack Obama) has been editor and publisher of the *New Pittsburgh Courier* since 1997. Doss has spearheaded numerous committees and special projects, survived changes in ownership, worked in various positions, and served on countless community and civic boards, as he has witnessed many changes during his 40-year career. While maintaining its longstanding role as a source of news, the *New Pittsburgh Courier* aims to positively portray and represent the African American community, as it has for nearly a century. For much of that time, Doss has had a hand in that mission. He is quick to credit the success of the paper to having good people around him. His tireless dedication and commitment have ensured the *Courier*'s historic success. The Allegheny County Board of Commissioners and Pittsburgh City Council honored Doss in 1997 for his 30 years of service with the paper. (Courtesy of Rod Doss.)

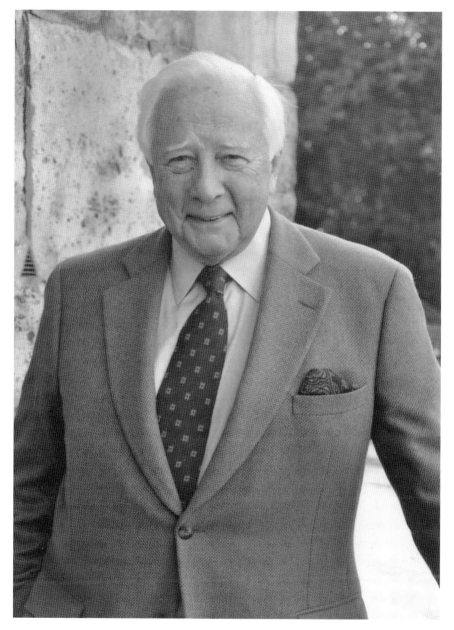

Native Son

Renowned author and two-time Pulitzer Prize and National Book Award winner David McCullough remains devoted to his Pittsburgh roots. His family lineage can be traced to before the Revolutionary War. In July 2013, the Sixteenth Street Bridge, linking the North Shore to the Strip District, was renamed in honor of this native son and respected historian. The event coincided with McCullough's 80th birthday. Known for his best-selling books *Truman, The Johnstown Flood, John Adams, 1776*, and, most recently, *The Greater Journey*, McCullough is also recognized as the narrator of the Ken Burns documentary *The Civil War* and the PBS history program *American Experience*. McCullough was the 2006 recipient of the Presidential Medal of Freedom and the Medal for Distinguished Contribution to American Letters in 1995. (Photograph by William B. McCullough.)

Sebak *Is* Pittsburgh (LEFT AND OPPOSITE)
Rick Sebak's name, ever-smiling face, and distinctive voice trigger instant recognition, validating his expression, "Pittsburgh's like that!" He was born and raised in Bethel Park. It would be rare to find a local resident who has never heard of Sebak (pictured on the opposite page above at center with his high school debate team and below while working on a production). Best known as the writer, producer, and narrator of WQED's Pittsburgh History Series and dozens of documentaries for public television, his most recent production, *25 Things I Like about Pittsburgh*, coincided with Sebak's 25th anniversary at the station. WQED honored Sebak with a program, *What Makes Rick Tick*, and the City of Pittsburgh declared the first week of December 2012 "Rick Sebak Week." Sebak's topics have included neighborhoods and landmarks, the well-known, and the unknown. He has won 10 Mid-Atlantic Emmys for his Pittsburgh programs, and was nominated for two national Prime Time Emmys for his work on the PBS documentary *Fred Rogers: America's Favorite Neighbor*. His 1988 program *Kennywood Memories* won the Ed King Memorial Award from the Press Club of Pittsburgh, and it remains a remarkably popular program with local audiences a quarter of a century after its premiere. Calling his programs "scrapbook documentaries," Sebak delivers fascinating human-interest stories with historic background about the people, neighborhoods, and businesses of the city he loves. As Pittsburgh's designated tour guide, he is a master at connecting Pittsburghers, reminding his audience of the best places to eat and things to see and do, whether they are first-time visitors or lifelong residents. (Courtesy of Rick Sebak.)

Children's Author

Best known for her Judy Moody series of books, children's literature author Megan McDonald was born and raised in Pittsburgh as the youngest of five girls, who served as inspiration for her characters and their adventures. In June 2011, the film *Judy Moody and the Not Bummer Summer* was released, staring young actress Jordana Beatty as third-grader Judy. Beatty is pictured here with McDonald on the movie set. McDonald is the author of more than 60 books for children, including *Bridge to Nowhere*, the story of a young girl coping with her father's depression as an unemployed ironworker. The book mentions Pittsburgh's incomplete construction of today's Fort Duquesne Bridge and an incident in 1964. She has also authored the Julie Albright book series for the American Girl doll of the same name. Her books have been translated into 22 languages. Though she currently resides in Sebastopol, California, Megan has never forgotten her Pittsburgh roots. (Courtesy of Greg Hammerquist, Candelwick Press.)

Pittsburgh
Forget those rotting hulks of steel,
this city is a woman.
Prove it: enter her by air
and see those contours,
these rivers and rolling hills.
Enter her from the Fort Pitt Tunnel
into a festival of light,
city of bridges, city of painters and poets.
Were I to paint her, this woman,
I would place her
near the top of 18th Street
with the sky behind her.
The unifying images of the picture
would be gray eyes
and the recent memory of yellow leaves.
(From *The Snake Charmer's Daughter*; © 2000 Michael Wurster)

Pittsburgh Poet Laureate

Michael Wurster, crowned Poet Laureate, has lived in Pittsburgh since 1964. Along with four others, he cofounded the Pittsburgh Poetry Exchange, a community-based organization of local poets. He taught poetry and poetry writing at the Pittsburgh Center for the Arts for 17 years (1993–2010). His poetry collections include *The Cruelty of the Desert, The Snake Charmer's Daughter,* and *The British Detective.* In 2008, he coedited, with Judith R. Robinson, *Along These Rivers: Poetry & Photography from Pittsburgh* as part of the Pittsburgh 250 Celebration. In 1996, Wurster was the inaugural recipient of the Harry Schwalb Excellence in the Arts Award, given by *Pittsburgh* magazine, for his contributions to poetry and the community. (Photograph by Heather Mull, courtesy of Michael Wurster.)

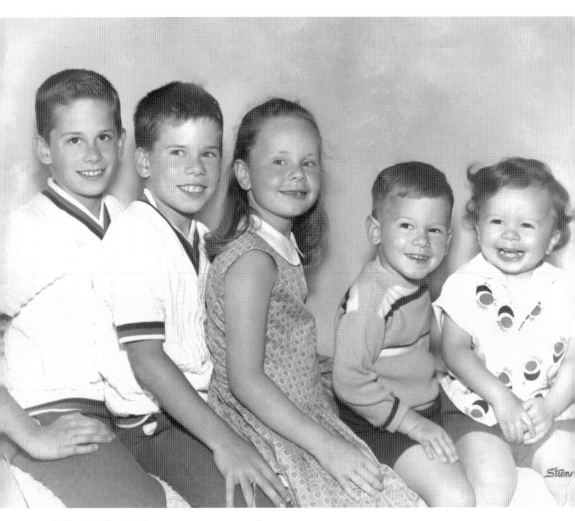

All in the Family (ABOVE AND OPPOSITE PAGE)

It is no wonder that the talented Steigerwald clan (above, from left to right) Bill, John, Mary, Paul, and Dan, all ended up working in the media and journalism. Raised in the South Hills by their sports-mad dad Bill and literate mother Kay, they grew up in a Ryan home filled with newspapers, magazines, books, jazz, and spirited talk about sports and politics. Oldest brother Bill became a writer/editor/columnist at the *Los Angeles Times* in the 1980s before moving home to join the *Post-Gazette* and *Pittsburgh Tribune*. In 2012, he authored *Dogging Steinbeck*, which exposed *Travels With Charley* as a highly fictionalized account of John Steinbeck's famous road trip. John established Steigerwald as a regional household name in the 1970s, becoming a television sportscaster for WTAE and then KDKA for three decades. He has hosted radio talk shows, written weekly newspaper columns, and penned two books, *Just Watch the Game* and *Just Watch the Game (Again)*. Paul, a part-time sports reporter at KDKA-TV while in the Pittsburgh Penguins marketing department, became the Pens' radio color analyst before assuming his current duties as the team's television play-by-play man. Mary, who has lived out West since the 1970s, was a writer for *Mothering* magazine and is now a creative craft artist living in New Mexico. Youngest sibling Dan, a gifted rock musician, went to Los Angeles and became the lead guitarist of Kingdom Come, a band that played in front of millions of fans on three continents and sold a million records in 1988. Not bad work for five legendary locals from the crowded suburban streets of Scott Township. On the opposite page, the Steigerwalds are pictured today, from left to right: Bill, John, Mary, Paul, and Dan. (Courtesy of the Steigerwald family.)

A Musician's Musician (ABOVE AND OPPOSITE PAGE)

Once called "the consummate jazz musician" by Fred Rogers, Joe Negri (above right, with Bob Hope) is one of the most recognized names in Pittsburgh, renowned as one of the top jazz guitarists in the country. For more than eight decades, he has been a tireless entertainer and educator, remembered for his contributions to the Pittsburgh music culture in addition to his longtime role on the PBS show *Mister Rogers' Neighborhood* as the easygoing "Handyman." As a composer, he has written music for numerous documentary film scores, including *The Crossing* (scored for brass band and jazz trio), and he penned a method book, *A Common Sense Approach to Guitar Improvisation*. Negri was born and raised on Mount Washington. Music has been part of his life for as long as he can remember, including singing by the age of four on KQV radio. Prior to becoming a guitar prodigy, Negri performed in 1931 for local dance studio owners Gene and Fred Kelly. That same Gene Kelly later became the world-famous dancer and actor. Negri found fame staying in his hometown. By the time he was 16, he joined the Pittsburgh Musicians' Union and performed with one of the country's top swing bands. He soon joined the national tour and became a featured player. In the 1950s, he began formal musical training at Carnegie Tech (now Carnegie Mellon University), preparing for what would be a 40-year career, starting at KDKA-TV and leading to a position as musical director and on-air performer at WTAE-TV. Negri married Joni Serafini, made his home in Pittsburgh, and raised three daughters. Through the years, he has worked with Tony Bennett, Andy Williams, and, most recently, with Michael Feinstein on the album *Fly Me to the Moon*. A few of his other albums include *Afternoon in Rio, Uptown Elegance, Guitars for Christmas,* and *Dream Dancing*, all recorded in Pittsburgh. Negri (opposite) is an adjunct professor of guitar at Carnegie Mellon, the University of Pittsburgh, and Duquesne University, where he received an honorary doctorate. Among countless awards, he received the Creative Achievement Award from the Pittsburgh Cultural Trust and the coveted Elsie Award (named for philanthropist Elsie Hillman), an honor given to Pittsburghers who have demonstrated a love of community by making a positive impact. Duquesne University recently established the Joe Negri Jazz Guitar Endowment Scholarship. (Opposite photograph by Max Leake; courtesy of Joe Negri.)

Father of Ballroom Dancing

Light on his feet, with rhythm and style that mirrored Gene Kelly, Tony Cardinali had charisma that captivated audiences. Born and raised in Sezze, Italy, he immigrated to Toronto after World War II and later came to the United States. On a trip to Pittsburgh in 1968, he fell in love with the city and made it his home. He bought a failing Arthur Murray studio downtown, and it did not take long until the Sixth Street studio had 120 students and was thriving, prompting the establishment of studios in Monroeville, McCandless, and Peters Township. Dancing became Cardinali's passion, and students loved him as a teacher and Arthur Murray franchise owner. Cardinali became known as the Father of Ballroom Dancing and operated the Sixth Street studio for 44 years. A master franchiser for Arthur Murray International Inc.'s Pittsburgh market, he eventually sold the franchises outside of Pittsburgh while continuing to hold the master franchise rights for the Greater Pittsburgh area. He was instrumental in motivating hundreds to use their God-given talents and perform their best. Until his death at the age of 82 in 2012, Cardinali devoted his life to igniting people's spirits and gifts. His son, Mario Cardinali, and daughter, Claudine Wonders, are following in their father's "dance steps" at the Arthur Murray Dance Studio in Wexford. (Courtesy of Mario Cardinali.)

Keeping the Beat

Roger Humphries picked up a pair of drumsticks as a toddler and has been impressing audiences ever since. Born on the North Side, the youngest of 10 children, Humphries was sitting in at local clubs by the time he was 12. After high school, he went on the road and soon was on the fast track in the jazz circuit, playing alongside many of the greats. He returned to Pittsburgh in 1969 and formed R.H. Factor, still headlining at jazz festivals and local clubs and events. With a strong interest in helping young musicians, Humphries has been a faculty member of jazz and percussion at the Pittsburgh School for Creative and Performing Arts (CAPA) and encourages students to interpret and improvise jazz standards at jam sessions and gigs around the city. (Courtesy of Roger Humphries.)

America's First Songwriter
Stephen Collins Foster, known as the "father of American music," was born in a cottage in Lawrenceville in 1826. Primarily known for his parlor and minstrel music, Foster wrote nearly 200 songs in his short and tragic life. Among his best known are "Oh! Susanna," "Camptown Races," and "Beautiful Dreamer." The sentimental ballads and melodies composed by Foster have remained popular for more than 150 years. A troubled man, Foster became impoverished and died at the young age of 37. He is buried in the Allegheny Cemetery in Pittsburgh. (Courtesy of University of Pittsburgh Historic Photographs, Archives Service Center, University of Pittsburgh.)

CHAPTER EIGHT

Leaving Footprints

Andrew Carnegie devoted the last 18 years of his life to philanthropy. Believing that personal wealth should be shared, he donated funds for nearly 3,000 libraries, parks, and facilities for education and the arts. He set an example that was followed by the generosity of the legendary families of Pittsburgh: Mellon, Heinz, Buhl, and Phipps, who established corporate endowments and grants to last for generations. Pittsburgh continues to have a reputation as one of the most active philanthropic and foundation communities, with groups like the Buhl Foundation committed to making a positive impact.

Today, the Fred Rogers Company honors its founder, building on his legacy in new and innovative ways. The company thrives by extending its work through partnerships and collaborations that connect a new generation of children, families, and educational providers with Rogers' timeless wisdom.

Yet the impression of footprints throughout Pittsburgh have been left not only by foundations, but by individuals, who have become legendary in their own right by the good works that they do for others. From Michele Fetting's efforts in bringing back the Pittsburgh Marathon, to Fr. Lynn Edwards's courage to minister to AIDS victims, the spirit of giving, serving, and showing compassion to humanity is evident in the everyday heroes who have become the legendary locals of Pittsburgh.

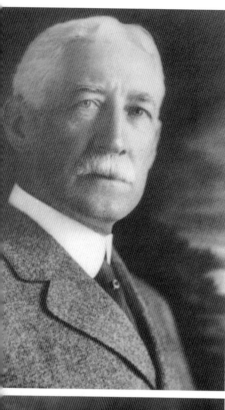

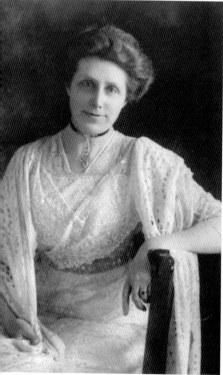

First Foundation

Henry Buhl Jr. built his fortune in the retail industry with his partner, Russell Boggs, operating Boggs and Buhl Department Store, which served the carriage trade of western Pennsylvania. Buhl was known as a hard-working, honest, and good citizen. He realized that there was more to life than money. He had achieved success beyond his dreams, but with no children and no direct heirs to bear his name and carry on his business, Buhl wrote his will in honor of his wife, Louise (below), with the intention of creating a foundation that would invest and reinvest in the well-being of the citizens of the city of Pittsburgh and Allegheny County. In 1928, the Buhl Foundation became the first multipurpose foundation in Pittsburgh, endowed with $11 million—one of the 10 largest of such foundations in the country. (Courtesy of the Buhl Archives.)

Viva San Rocco

On a weekend in August each year, near the feast day of San Rocco on the 16th, the community of Aliquippa gathers its resources, talents, and neighborly love to celebrate an ethnic tradition born of old-world Italy memories. The San Rocco Festa is distinguished as the longest continuously running ethnic celebration in western Pennsylvania. The photograph above right, from 1949, shows Festa girls carrying the original San Rocco banner, made in 1926 when the community of Aliquippa had the name Woodlawn.

Three of the six founders of San Rocco Festa are shown in 1957 in the photograph below left. They are Pio Colonna (far left), Joseph Paladini (third from left), and Dominic Montini (far right).

The San Rocco statue, purchased in 1957, is seen below right as it is carried during the 1964 Festa procession in a hand-carved cupola. The men in robes fast during the mass and procession, while others eat and drink from tables set up in homes. (Courtesy of David Colonna and the San Rocco Cultural Committee.)

Inspired to Give

Serving others and giving back are tenets that were instilled in April Brouwer's young life through her Catholic education and close-knit family. Before working as a project development specialist with Chester Engineers, she joined the Peace Corps. It was an easy decision, knowing that her time could help someone who needed assistance. Brouwer spent a little over two years in Gambia, a period that changed her perspective on life. She returned home to serve as a pastoral council member at St. John Neumann Parish in the North Hills. She is a board member at North Hills Community Outreach, with new responsibilities as chairwoman of the strategic planning committee. As if she was not busy enough, Brouwer volunteers her time with the international nonprofit Workforce Development Global Alliance on development projects in Kenya, and mentors youth. With the belief that each day is a chance to serve, Brouwer approaches others with a willingness to listen, show compassion, and act with love. She aims to live her life inspired by Mother Teresa's words, "Not all of us can do great things. But we can do small things with great love." (Courtesy of April Brouwer.)

Rally for Runners

When Michele Fetting decided to take up running as a way to meet people and get in shape, she became passionate about it and, over time, completed nine Pittsburgh Marathons. She joined the organization's board of directors, and when financial problems forced the city to cancel the event in 2004, Fetting was disheartened about the loss of a signature Pittsburgh event.

In August 2007, Fetting was diagnosed with non-Hodgkin's lymphoma, yet she continued to work tirelessly with city legislators and through three mayors, attending countless meetings in an effort to find a sponsor and bring back the marathon. While raising a young family, going through chemotherapy, and enduring the most aggressive and effective treatment available—a grueling autologous stem cell transplant—she pursued her vision of a return of the Pittsburgh Marathon. Fetting believed strongly that the race was good for the city, but she also believed there were thousands of others who also wanted to see the event come back. In her own words, Fetting described the event: "The rivers, the people, the music, the smell of barbecue and most of all, the beautiful topography of Pittsburgh—this is what defines our marathon. You can't find anything like it anywhere else in the world."

On May 3, 2009, after a five-year absence, the Pittsburgh Marathon finally returned to the city. More than 10,000 runners were greeted by thousands lining the streets, welcoming them back and grateful for the persistence of a dream. By 2012, the Pittsburgh Marathon more than doubled in size and included runners from all over the world. (Courtesy of the *Pittsburgh Post-Gazette*.)

His Heart's in Pittsburgh

On May 18, 1981, Brian Reames became the fifth heart transplant recipient at Presbyterian Hospital in Pittsburgh, the same year that Dr. Thomas Starzl arrived. Reames realized the need for support for pre- and post-transplant recipients who faced myriad issues, and he banded together the support of hospital administrators and a small group of recipients and their families to form TRIO (the Transplant Recipients International Organization). It was first known as TRIP (Transplant Recipients in Pittsburgh). As the organization's first president, Reames became immersed in issues and routinely spoke throughout western Pennsylvania on the need for donor awareness, appearing on national news and talk shows. In 1984, Reames worked with Sen. Al Gore on the National Organ Transplant Act. Reames and his wife, Mary, were faithfully committed to the ideals of TRIO, and they were grateful for his second chance on life and the gift of time to raise his young children Tony and Susan (left). Reames died in February 1988 from complications resulting from a second transplant. In 2012, Brian Reames was honored at the 25th anniversary Celebration of Life dinner for his remarkable dedication to organ transplantation. (Courtesy of Mary Reames.)

Brian Reames '68

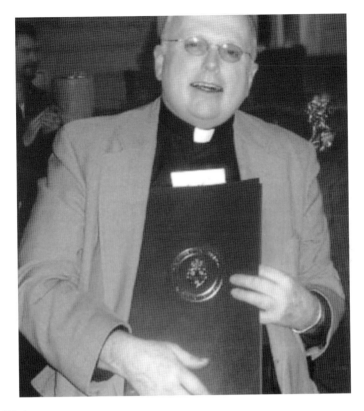

Courage to Minister

The longtime pastor for Shepherd Wellness Center, Fr. Lynn Edwards reached out to help AIDS patients at a time when others were too frightened to do so. His destiny in life remained a mystery until the late 1980s, when he heard about a strange disease affecting gay men. Something stirred inside, as Father Lynn realized that God had plans for him to begin a unique ministry. When he attended a meeting of the recently formed Pitt Men's Study, he heard of the need for those infected to have a social place where they could bring their loved ones, as well as a place of gentle spirituality. Without hesitation, he offered his church as a place of refuge. Many believed in the early years that the disease was carried through the air, and there was great fear in visiting the hospital rooms of dying AIDS patients. It was because of this that Father Lynn and a few other pastors formed the Ministerial Network on AIDS, to show compassion and educate the public. When the first meeting was organized, the name Shepherd Wellness Center (later changed to Shepherd Wellness Community) was chosen, after the Church of the Good Shepherd, Father Lynn's church in the Hazelwood section of Pittsburgh. Out of the first meetings came the idea that it should be a place to share meals and show there was no fear of eating together. Fear was the operative word 25 years ago, in a time when persons with AIDS were treated as outcasts. When the group first began to meet, Father Lynn asked the police to patrol the church on their rounds of the neighborhood. At first, police kept watch from a safe distance, equipped with rubber suits and gloves. Another time, a caterer, discovering that the people in the church had AIDS, dropped the food off in the snow, about 25 feet from the door. If fear was the operative word, loneliness was a close runner-up. In those early years, Father Lynn was presiding over a funeral nearly every other week for victims. Often, no family members were present. The AIDS crisis is not over today, but people infected and affected by the disease have a place to bond in Pittsburgh. Providing care and support, The Shepherd Wellness Community is a place where one person can say to another, "I know where you are, because I've been there." (Courtesy of The Shepherd Wellness Community.)

Thinking Outside the Cage

As director of communications for Animal Friends since 2006, Jolene Miklas has become something of a celebrity. She works to build relationships by informing and engaging the community in the way an animal shelter operates. She works with many animals along the way, finding families to adopt the city's homeless pets while devoting herself to Animal Friends' no-kill policy, refusing to euthanize due to overpopulation. Miklas began her undergraduate career at the University of Pittsburgh as a writing major. In May 2003, she accepted a job at Animal Friends, Pittsburgh's longtime organization dedicated to the adoption of pets. Miklas's endearing personality and pleasant demeanor made her a perfect fit for public appearances and as a spokesperson for the Adopt-A-Pet segments on KDKA's *Pittsburgh Today Live*. In the segments, Miklas introduces the community to animals at the shelter, to gain exposure and hopefully find homes and generate many new adoptions. An animal lover her entire life, Miklas proved she walked the walk when she agreed to foster Porter, a sick beagle. He was rescued when the other dog in his home was bludgeoned to death by the owner. Porter was traumatized when he arrived. His ears had been sliced with scissors and he had heartworm, a potentially fatal disease. He spent almost three months recovering in her home, slowly becoming a sturdy, happy, healthy, and well-socialized beagle. The only problem was, Miklas could not let him go! Porter is now a permanent member of Miklas's family. Animal Friends rescues, shelters, and finds homes for abused and abandoned animals. It spays or neuters over 10,000 dogs, cats, and rabbits every year and offers pet-focused outreach programs that take pets into schools, hospitals, and nursing homes. (Courtesy of Jolene Miklas.)

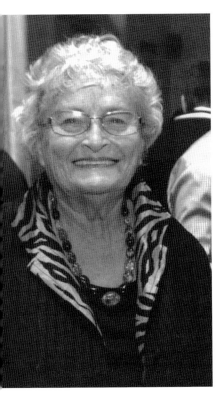
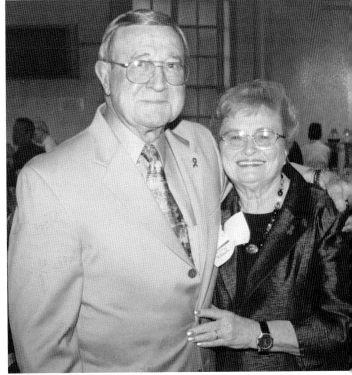

Looking for Magic

In 1990, it was a very difficult and dark time for Beverly Pollock, pictured above right with her husband, Mel. She was preparing to go to California and take care of her son during the last months of his young life. She questioned what to tell the neighbors. "The truth," her husband, Mel, replied without hesitation. "What else?" The cold hard truth was that their 35-year-old son, Bobby, was dying of AIDS. In the not-so-distant past, there was no cure. There was a zero percent survival rate, and almost everyone diagnosed with HIV died quickly. For families in the early years, the fear of being shunned or ostracized if someone found out that one of their loved ones had AIDS was so great that it far outweighed any benefits of going public. Shortly after her son's death, Beverly looked for any resource or agency in Pittsburgh to offer support, and discovered The Shepherd Wellness Community, still serving today as the only AIDS community center in western Pennsylvania. Beverly and Mel faced the repeated devastating heartache when they lost another son, Larry, who also died of AIDS, in New York in 1995 at the age of 48. Beverly tried to see something positive out of something so unbearable. Then, community became family and she found a strength she never knew she had. In the two decades that followed, Beverly continued as one of the most vocal advocates of the Shepherd Wellness Community, serving on committees, volunteering, and raising funds. She worked tirelessly for those living with HIV and their families, consoling countless grieving parents. She received a Community Champions Award for her dedication to the AIDS community in 2005. In 2011, at age 87, Beverly wrote a play, *Looking for Magic: A Modern Tale of Parents, Coming Out and AIDS*, to reflect the changes since 1991 and to raise awareness of the impact of HIV on families. The play was produced with Equity actors and a director at the Henry Heymann Theatre in the University of Pittsburgh's Stephen Foster Memorial to coincide with World AIDS Day 2011, benefiting the Shepherd Wellness Community. In 2012, Beverly bid a fond farewell to the city she has called home for 55 years and to the Shepherd Wellness Community when she moved to Arizona. She will never forget how much it meant to have the genuine empathy, understanding, and support of others in her time of need. She is grateful that the picture of AIDS has changed and the disease is no longer a death sentence as it was in the early years. (Courtesy of Beverly Pollock and the Shepherd Wellness Center.)

Simply James

Pittsburgh native James Buckley returned to writing and performing music after a 20-year absence, having begun his career in the early 1980s. His music, covering all aspects of life, was written from his heart and soul. He relied on his own experiences and on those of the people that he met. From his early years as a cab driver, Buckley has always been a great listener, with an ear for a good story. The songs he wrote were influenced by the genuine belief that life should be spent caring for others. He sings and feels the connection and emotions of his audience, and he performs with a band of men who have great chemistry and are like brothers. His life changed as a teenager when he attended Central Catholic High School in Pittsburgh, thanks to the generosity of a parishioner. It was then that Buckley realized that everyone is put on this Earth to help others, directly or by example. (Courtesy of James Buckley.)

Playing It Forward

Built around the foundation of paying (or "playing") it forward, Buckley and his band effectively touch the hearts of their audience, through the arrangements and presentation of their songs. Buckley has been involved with charities and nonprofit organizations too numerous to count, including Children's Hospital, The Pittsburgh School for the Blind, the Children's Home of Pittsburgh, Our Lady of the Most Blessed Sacrament Parish, The Autism Society, Hillman Cancer Center, and the US Marines Corps' Toys for Tots program. Known citywide for his charitable concerts and music therapy at hospitals and nursing homes, as well as his work with youth, Buckley sees music as a powerful way to bring people together and provide strength. (Courtesy of James Buckley.)

Living Miracle (ABOVE AND OPPOSITE PAGE)
An unsung legend in his own right, Donald "Donnie" Bugrin II (pictured opposite in 1973) was one of the oldest lifelong patients at Children's Hospital of Pittsburgh, from his birth in 1969 and continuing through adulthood because of his long history with doctors there. Born with congenital heart defects, he had a history of close calls, but each time, he recovered and defied expectations. Time became his ally. Though Donnie's initial prognosis was bleak, each year that he lived was another year of medical advances and new technologies in cardiac care. Though his heart condition and deformities were uncommon and threatening, he won every time the cards seemed stacked against him. Donnie was known as a medical marvel and a living miracle. In his 30s, while married with young children of his own, he continued to have annual checkups at Children's Hospital. He would often make light of the situation, as the man sitting among a group of kids in the cardiologist's waiting room. Doctors saw Bugrin as a model patient who kept a positive outlook and built a normal life despite a lifetime of complex heart problems. Expected to live not much past the age of five, he survived many life-threatening experiences and had surgeries in 1979 and 1987 to improve his heart function. Bugrin graduated from North Catholic High School and La Roche College and was working for a mortgage company in Pittsburgh at the time of his death in 2006. Loved by all who knew him, he had a legion of family, friends, and acquaintances who prayed for him and rallied for him every time he fell ill. Doctors praised him and marveled at the normal and productive life he led, as most patients with similar problems could never psychologically overcome the bad hand they were dealt. At his funeral, so many people who considered themselves to be his best friend wanted to be a pallbearer, that a procession was formed as a true testimony of love. Bugrin is pictured above in 2002 with twin sons Blake and Adam. (Author's collection.)

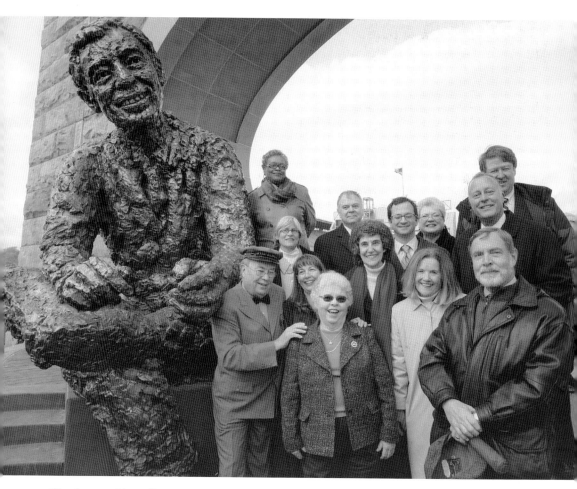

The Legacy Lives On

The Fred Rogers Company (formerly Family Communications) was founded by Fred Rogers in 1971 as the nonprofit producer of the children's television series *Mister Rogers' Neighborhood* for PBS. In the years that followed, the company not only created hundreds of episodes of this much-loved program, but it also extended Rogers' values and approach to other efforts in promoting children's social, emotional, and behavioral health and in supporting parents, caregivers, teachers, and other professionals in their work with children. In 2010, Family Communications was renamed to honor its founder. The staff continues to build on Rogers' legacy in innovative ways, extending its work to a wide variety of media. Through partnerships and collaborations, the company has developed new children's television programming, including *Daniel Tiger's Neighborhood*, broadcast daily by PBS, online, and via mobile activities and professional resources. The show connects new generations of children, families, and educational providers with Fred Rogers' timeless wisdom. (© The Fred Rogers Company, used with permission.)

INDEX

AN IMPRINT OF ARCADIA PUBLISHING

Find more books like this at
www.legendarylocals.com

Discover more local and regional history books at
www.arcadiapublishing.com